Our Point
OF View

Our Point of View

Fourteen Years at a Maine Lighthouse

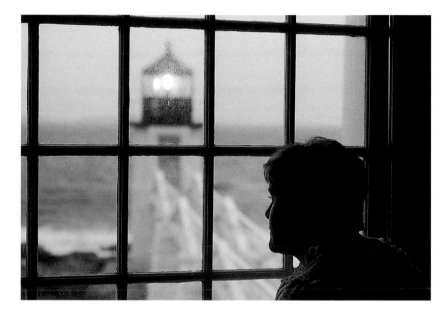

Thomas Mark Szelog and Lee Ann Szelog

Photographs by Thomas Mark Szelog

Foreword by Marge Winski, Keeper, Montauk Light

ISBN-13: 978-0-89272-704-9 ISBN-10: 0-89272-704-7

LIBRARY OF CONGRESS CATALOGING-IN-PUBLICATION DATA

Szelog, Thomas Mark.
 Our point of view : fourteen years at a Maine lighthouse / Thomas
Mark Szelog and Lee Ann Szelog ; photographs by Thomas Mark
Szelog.
 p. cm.
 ISBN-13: 978-0-89272-704-9 (trade hardcover : alk. paper)
 1. Szelog, Thomas Mark--Homes and haunts. 2. Szelog, Thomas
Mark--Diaries. 3. Szelog, Lee Ann--Homes and haunts.
4. Lighthouse keepers--United States--Biography. 5. Marshall Point
Light Station (Port Clyde, Me.)--History. 6. Lighthouses--Maine--
Pictorial works. 7. Port Clyde (Me.)--Description and travel. I.
Szelog, Lee Ann. II. Title.
 VK140.S94.A3 2007
 387.1'55092274153--dc22
 [B]
 2006027819

Design by Chilton Creative
Printed in China

5 4 3 2 1

DOWN EAST BOOKS
A division of Down East Enterprise, Inc.
Publisher of Down East, the Magazine of Maine

Book orders: 1-800-685-7962
www.downeastbooks.com
Distributed to the trade by National Book Network

To Marge Winski, keeper of the Montauk lighthouse.

A special place in our hearts is forever reserved for you.

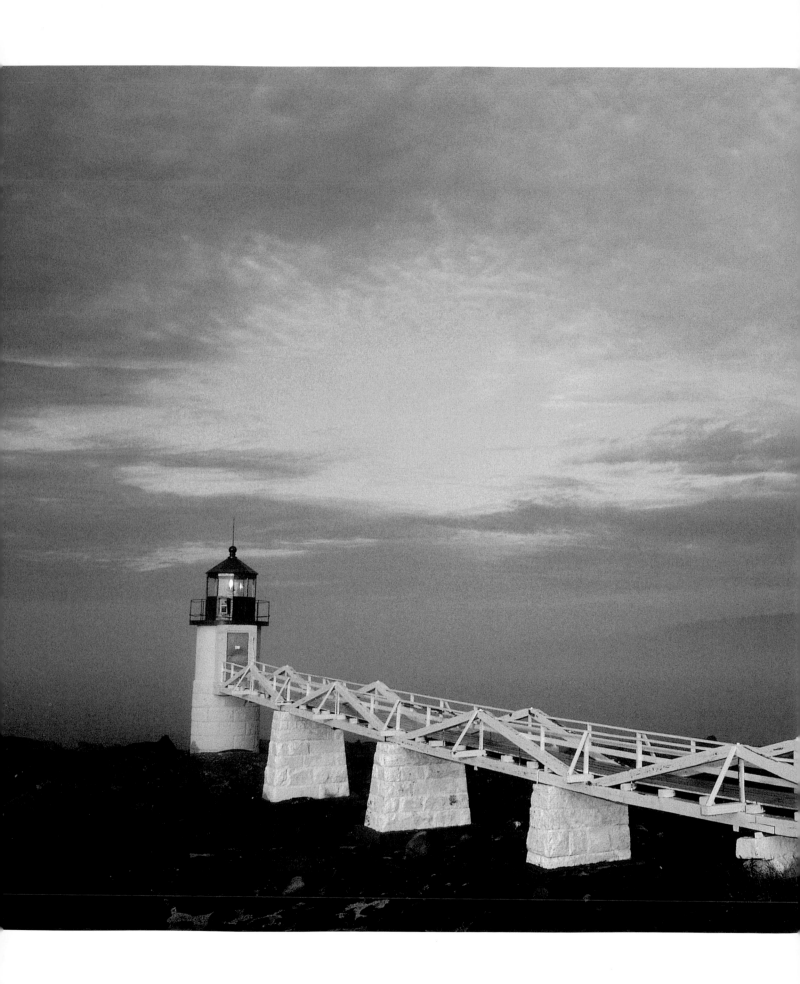

Contents

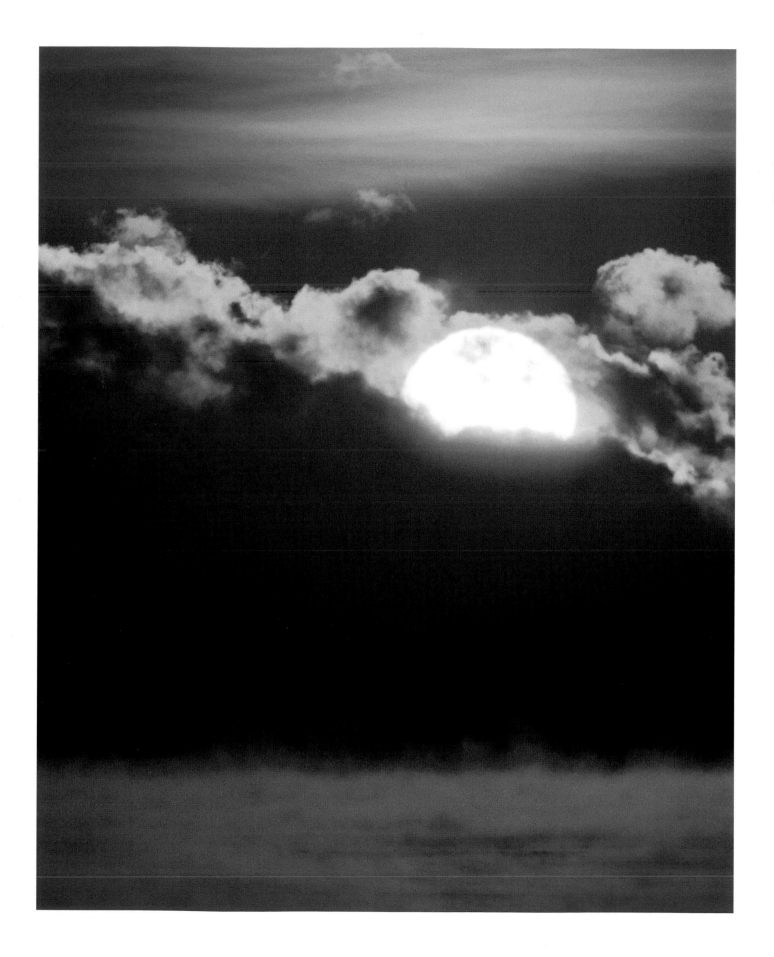

Foreword

In the twenty-first century, lighthouse keepers are perhaps considered an anachronism, unnecessary when computer chips can control beacons and foghorns. Gone are the stalwart men and women who not only lived in lighthouses but also lived for lifesaving—people who realized their true vocation. Lightkeepers were willing to endure a rugged, insular existence, coping with extreme weather in often remote locations with little outside contact. But no matter how difficult the living conditions, they must have been more than mitigated by the joy and wonder of experiencing the world around the lighthouse.

Although the traditional lightkeepers are extinct, there is a new breed of keeper—lighthouse residents whose heart and soul are bound to the "wickies" of old, even though they might not be directly responsible for the mechanics of the light apparatus. These people are vigilant, compassionate, and concerned for the safety of their seagoing brethren and passionate about the natural world around them.

Lightkeeper Marge Winski in the lantern room at Montauk Light

Many years ago, I read a magazine article about Tom and Lee Ann Szelog's life at the Marshall Point lighthouse. Intrigued, I decided to write them a note. Since then, we have become very good friends, relating our experiences in lengthy letters, an old-fashioned yet simple and eloquent means of communication. We share a kinship with our interest in natural history and cherish our observations of the world outside the windows.

Simple pleasures offer us great joy: watching the sun rise from the sea each day, feeling the cool mist of fog brush our cheeks and laden our eyelashes, breathing the aroma of the sea when we open the door. Nights filled with stars, meteors, and bats hunting insects in the lighthouse beam. Exclaiming with wonder and surprise at the breaching of a great whale just offshore, watching seals cavort in the water or lounge on the rocks at low tide. Being a rest stop in the great migrations of birds, fish, and even butterflies. Watching the moon rise and engrave the sea with a glassy sheen as waves corrugate the surface. The unbounded joy of sitting inside the lantern room during a blizzard as a maelstrom of white swirls all about. Meeting so many wonderful people who are drawn to the magic of life on the coast.

I feel very fortunate to have met Tom and Lee Ann, whom I now consider to be part of my family. Their love for Marshall Point is infectious. Tom's extraordinary photographs chronicling their lighthouse sojourn convey their true love and respect for a most beautiful part of my favorite state. I hope you will enjoy a glimpse into their world through words and images of splendid isolation on the edge of the sea and will come to treasure Tom and Lee Ann as I do.

Marge Winski, Keeper
Montauk Light
Montauk, New York

At Home in the Keeper's House

On December 1, 1987, I awoke with childlike excitement. Looking forward to my second date with Tom Szelog, I never dreamed how meaningful this day would become—not only leading to our marriage but also leading to the publication of this, our first book.

Tom also had been anticipating this day. Our plans included visiting some of southern Maine's most prominent lighthouses. This seemed an appropriate way to become better acquainted, since it was our mutual admiration for lighthouses that had attracted us to one another in the first place.

Our first stop was Nubble Light in York, Maine—one of my favorite lighthouses—where I had spent many days privately observing, romanticizing, and contemplating. It was at this first stop that I shared with Tom a dream of mine—to live in a lighthouse.

This dream—which Tom soon came to share—became reality on September 23, 1989, less than two years later, when we moved into the newly restored keeper's house at Marshall Point Light in Port Clyde, Maine. This would be the beginning of fourteen extraordinary years.

I had learned about the availability of the house, and its volunteer opportunities, from a notice posted on a community bulletin board. The keeper's house was being renovated to include a museum on the first floor and an apartment on the second floor. The leasing of the apartment (the keeper's quarters) would allow the house to continue to be used for its original purpose—a home—and the income from the rent would be used for maintenance. After submitting a two-page letter to the lighthouse committee explaining why we'd be the perfect tenants, we were informed that we had been accepted.

Marshall Point Light is located in the working fishing village of Port Clyde, part of the town of St. George, with a population of less than three thousand. The ride down the St. George Peninsula to Port Clyde and Marshall Point is long and at times tedious, but a wonderful surprise awaits those who venture to this section of Maine's coast. Due south, twelve miles offshore, lies the island of Monhegan, with stunning sea cliffs. When the Monhegan Island Light shines distinctly at night, it is easily visible from Marshall Point. Marshall Point is one of the most beautiful locations in Maine. We have no doubt that, after seeing the lighthouse either firsthand or through this book, you will begin to understand the sense of awe and strong attachment we had for it.

~~

When we moved in, we quickly realized that the residents in the keeper's house were no longer conventional "keepers of the light." Modern technology has paved the way to automation, so we were part of a new generation. Even though we were not formally responsible for maintaining the night's beacon or the foghorn, however, we felt a sense of responsibility for maintaining a longstanding tradition. We voluntarily assisted the Coast Guard with some of the duties of lightkeeping. We swept the spiral staircase and polished the lens, and, like keepers of old, we braved nor'easters, trudging to the tower in the middle of the night when necessary to relight the malfunctioning lantern or reset the foghorn. As part of this effort, we considered it a privilege to meet the members of the Coast Guard Aid to Navigation Team (ANT)—the official keepers. They were proud of their work, and our relationship with them grew over the years. They regularly phoned us to check on the operation of the foghorn or light.

Our most poignant interaction with the Coast Guard ANTs occurred on that fateful day of September 11, 2001. As Tom and friend and client Chris Burt watched the events unfold on television, two Coast Guardsmen were performing regularly scheduled work on the tower. At approximately ten a.m., Tom received a phone call from a member of the Southwest Harbor (Maine) Coast Guard station asking him to inform the men to contact the base immediately. When they returned the call, they were ordered to get out

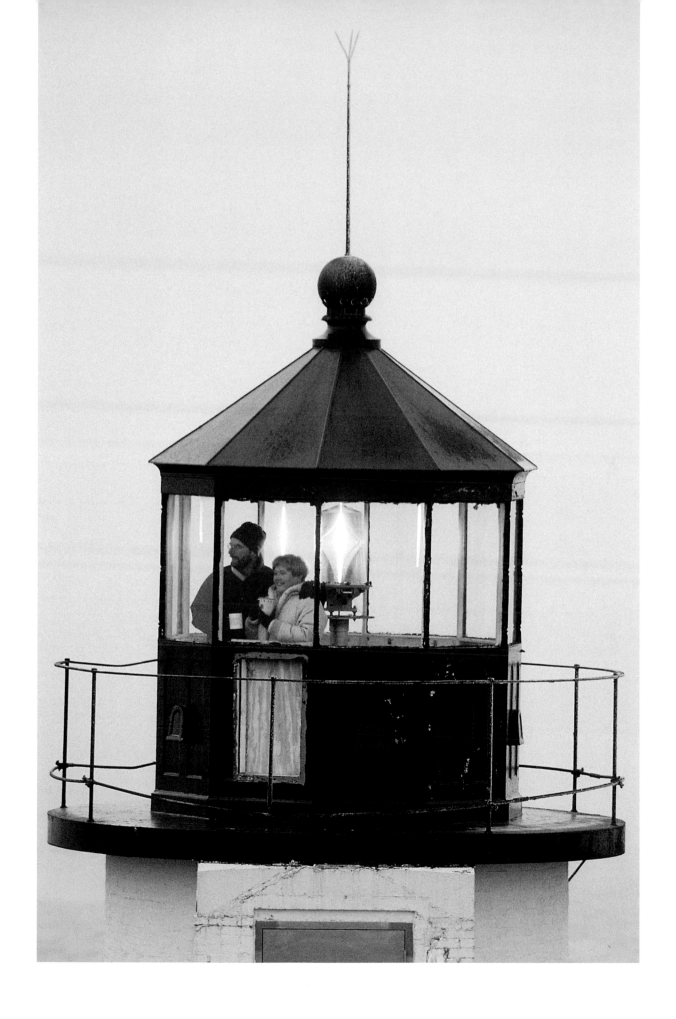

of uniform, retrieve their weapons, and return to their base at once. While we lived in the keeper's house, mundane chores always took on particular meaning. From washing the salt spray off the windows to baking with fresh fruit we had picked in our backyard, we treasured every task. We sustained the soul and passion of the sea, and the memory of lighthouses and lightkeepers of the past. We brought life back to the keeper's house, which had stood forlornly unoccupied for nearly a decade.

The light tower, the keeper's house, and the grounds are owned by the town of St. George and operated by the Marshall Point Lighthouse Museum Committee under the auspices of the St. George Historical Society.

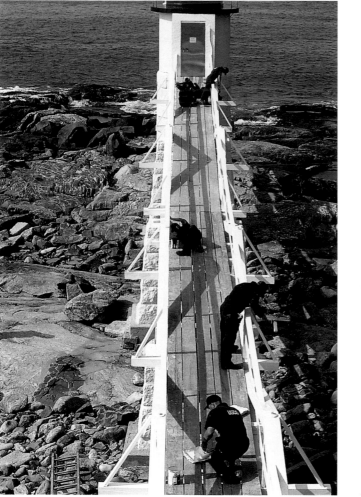

We were active members and volunteers with the committee and the museum. I was treasurer and the first female chair of the committee, which paid us a nominal fee for the daily cleaning of the seasonal museum. During the filming of *Thinner,* a movie based on a Stephen King novel, Tom was paid to operate the light when needed, but the biggest reward was our personal satisfaction.

The breathtaking beauty of this spot has drawn people day after day, year after year, decade after decade, century after century. It has always been a place of pilgrimage for many people, allowing us to witness myriad events—some quite extraordinary, others quite ordinary. During our almost fourteen-year tenure, Marshall Point welcomed thousands of visitors, some of whom have become lifetime friends. Others we met fleetingly while assisting with such crises as searching for a lost dog or cat, providing first aid for minor mishaps, and helping disabled motorists and mariners. And many times we simply answered the most frequently asked question: "What is it like to live in a lighthouse?" We even became pen pals with a third-grade reading class at Monte Cassino Elementary School in Tulsa, Oklahoma, who wrote to us and asked about our life in a lighthouse.

At first, I thought the end of summer would bring an end to the stream of people who visited Marshall Point nearly every minute of every day. But it did not. Weekdays, weekends, mornings, evenings, hot, cold, wind, and rain—they still came. They walked, sat, and reflected. They kayaked, flew kites, and fished. They took photographs and painted. They were quiet; they screamed. They were incredibly drawn to this parcel of jutting land. Some paused for a few moments, while others lingered for hours. They came, they went, but we stayed. We were the only ones who stayed. We remained through the heat, cold, wind, and rain. We made photographs and kept journals about our observations at an authentic lighthouse on the coast of Maine. We wanted to capture every detail of this remarkable spot.

Although journal writing was new to me, it was nothing new to Tom. He believes that without journals and photographs, the journeys of mankind cannot be shared. As a youngster, he kept personal journals about his wildlife encounters along the Merrimack River in his hometown of Manchester, New Hampshire. Those early writings are fascinating to read, full of first-time sightings of numerous animals and birds,

emphasizing the encounters with plenty of exclamation points. I may be one of the few people (or maybe the only one) with whom Tom ever shared these childhood journals. Being a reserved individual, he found it difficult to agree to publish selections from the private journals we kept during our fourteen years at Marshall Point Light. We both recognized, however, that the longer we resided at Marshall Point, the more special our documentation became. Through our journals and his photographs, we were chronicling the adventure of existing on the edge of the continent, recording life and death at Marshall Point. In this way, we were answering that most frequently asked question: "What is it like to live in a lighthouse?"

This body of work captures many intriguing and dramatic moments. To our knowledge, Tom is the only professional photographer to have lived in a lighthouse in the United States. Residing in an operating lighthouse granted him an unprecedented and unequaled perspective for photographing this quintessential symbol of fortitude and altruism. His home office allowed him the unmatched opportunity to study this place, its people, the landscape, and the wildlife—twenty-four hours a day, seven days a week, for fourteen years. Through the medium of color photography, his images explore, through the eyes of the lightkeeper, the mystique and allure of living in a lighthouse. The images exude romance, provide solace, and exert a powerful hold on the imagination and spirit.

This book is an autobiography, photo essay, history lesson, social commentary, and fairy tale. It is a true story, a love story. You will discover the wonders at Marshall Point Light just as we did—never knowing what might come the next day, the next month, or the next year. *Our Point of View* lets you observe what it's like to live only thirty feet from the Atlantic Ocean. At only seven acres, Marshall Point is a tiny piece of our planet, but it looms large in our hearts and minds. For us, it will always be a place of celebration.

Tom and I often thought that this land must have been heaven before humans settled here. Before the farms and homes, the land was raw—no roads, no lighthouse. Although it must have been even more spectacular and wild than it is today. Marshall Point remains one of those rare and unrivaled places. Now, turn the pages of this book; take time to let your mind drift. You will hear the harmonious sounds of gulls and waves. You will smell the intoxicating salt air and feel the wind fill the sails of a century-old schooner as it passes the even older light tower. You will travel into the past. The salt air is an elixir, a great psychological tonic. At times, it seems that there is no world beyond Marshall Point, where life's cares have a way of vanishing. Everyone takes home with them a fondness for and a memory of this most magnificent edge of land and sea. May *Our Point of View* inspire you to embrace simple pleasures and pursue your own dreams.

Lee Ann Szelog
Bear Brook Cabin, Whitefield, Maine

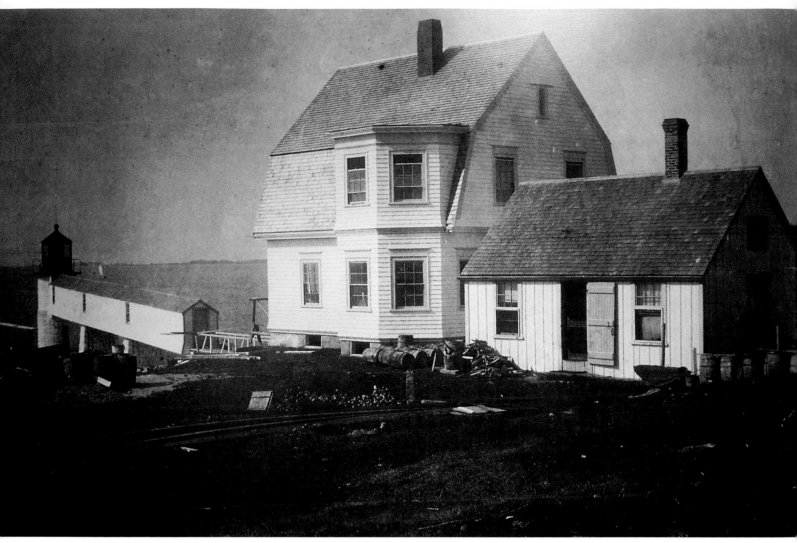

The keeper's house at Marshall Point, circa 1895. Note that the footbridge to the tower is covered, protecting the keepers from the harsh elements. National Archives photograph, courtesy of Marshall Point Lighthouse Museum

History of Marshall Point Light

* 1832—The first light tower, made of rubblestone, and the keeper's house, with 18-inch-thick stone walls, were constructed at a cost of $2973. John Watts, the first lightkeeper, kept the lights burning with lard oil.

* 1858—A new light tower was constructed and a fifth-order Fresnel lens installed. This 31-foot tower, made of brick and granite, is the one that stands and functions today.

* 1874—Charles Clement Skinner became lightkeeper. He held this position until 1919—making his the longest tenure of any lightkeeper in the United States at a single lighthouse.

* 1895—The keeper's house was destroyed by lightning.

* 1895—A new keeper's house was constructed. This is the house in which Lee Ann and Tom Szelog would eventually reside.

* 1935—The light was electrified, with a kerosene lamp serving as backup.

* 1939—The United States Lighthouse Service was discontinued. The United States Coast Guard assumed responsibility for the lighthouse.

* 1971—The light in the tower was automated, requiring no further need for a lightkeeper. Will Boddy was the last keeper. The Coast Guard converted the keeper's house into a LORAN navigation station.

* 1980—The Coast Guard LORAN station became obsolete. The keeper's house was abandoned, in disrepair. The town of St. George obtained a five-year lease on the grounds to keep the area accessible to the public.

* 1988—The town of St. George obtained a thirty-year lease from the Coast Guard for the keeper's house and the grounds. The Marshall Point Lighthouse Museum Committee, under the auspices of the St. George Historical Society, began to restore the keeper's house, and it was placed on the National Register of Historic Places.

* 1989—Tom and Lee Ann Szelog moved into the keeper's house.

* 1998—Ownership of Marshall Point Light was transferred to the town of St. George. The Coast Guard continues to maintain the light and the foghorn as active aids to navigation.

* 1990—The Marshall Point Lighthouse Museum officially opened in a section of the keeper's house.

* 2002—Tom and Lee Ann Szelog departed the keeper's house at Marshall Point Light, and new tenants moved into the second-floor apartment above the museum.

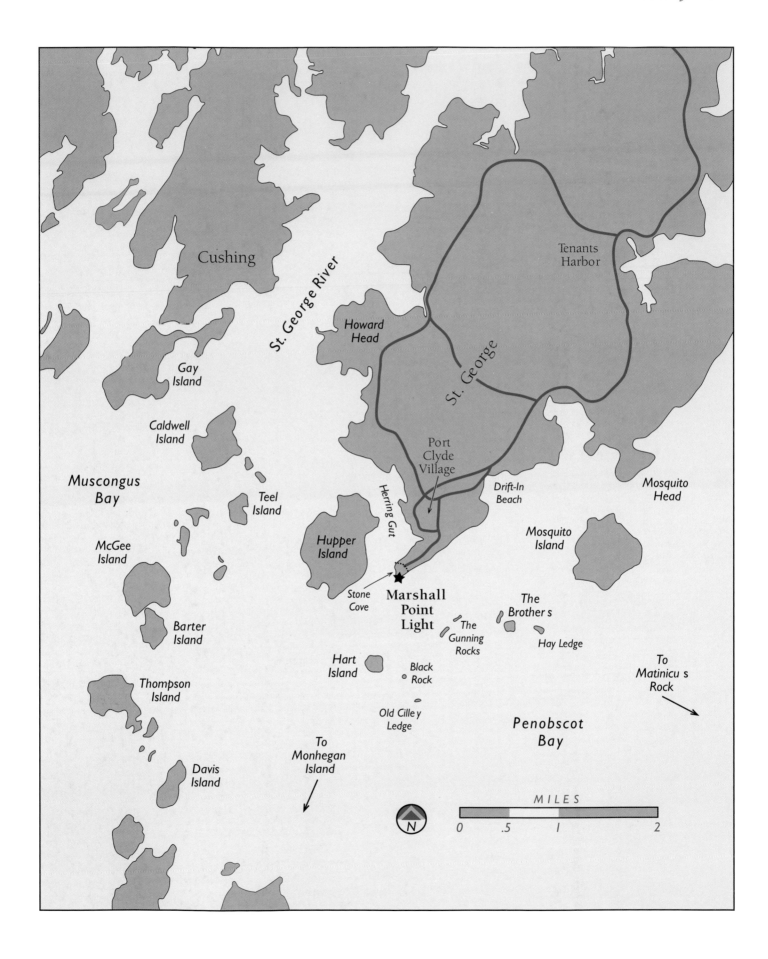

Cushing

St. George River

Tenants Harbor

Howard Head

St. George

Gay Island

Caldwell Island

Port Clyde Village

Mosquito Head

Muscongus Bay

Teel Island

Herring Gut

Drift-In Beach

Mosquito Island

McGee Island

Hupper Island

Stone Cove

Marshall Point Light

The Brothers

Barter Island

The Gunning Rocks

Hay Ledge

Hart Island

Black Rock

To Matinicus Rock

Thompson Island

Old Cilley Ledge

Penobscot Bay

Davis Island

To Monhegan Island

MILES

N

0 .5 1 2

Journal Entries AND Photographs

September 24, 1989

*T*oday is our first full day at our new home in the lightkeeper's house at Marshall Point in Port Clyde, Maine. Prior to our move to the lighthouse, Lee Ann and I often discussed the unique vantage point we would have for viewing approaching storms. Never did we expect to move our belongings in the midst of one. The forecast for yesterday called for a tropical storm with four inches of rain and 40 to 60 mph winds. We were excited at the prospect of starting our life at the lighthouse with a bang, but we were concerned about the impact it would have on our move.

We woke yesterday morning to dry air, partly sunny skies, a stiff wind of 30 to 40 mph from the south, and no rain. The storm took a route north of Maine into Canada. We were lucky.

~ *Tom*

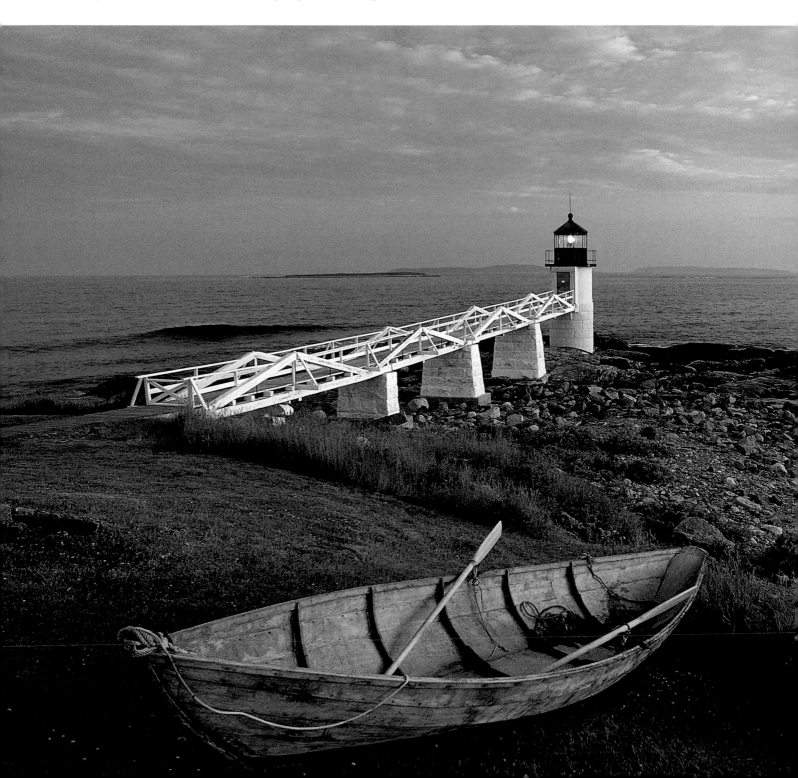

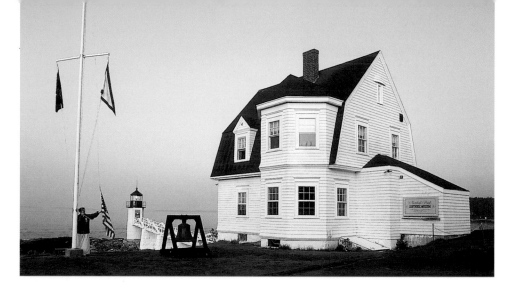

October 1

*O*ur fairy tale continues, with the prince (me) and the princess (Lee) vowing our love forever. (We were married yesterday.) Our life together is a fairy tale. Our affection for each other prospered from our mutual fascination with lighthouses. My artistic curiosity and Lee's love of the sea sailed us together to Nubble Light in York, Maine, on our second romantic date. Since that day, we've spent numerous mornings, evenings, full moons, rainstorms, and blizzards exploring the wavering moods of New England's lighthouses. Many of our reflective discussions revolved around our dream of residing in a classic lighthouse.

Little did we know that our dream would become a reality. The lighthouse at Marshall Point is now our home.

Again, our fairy tale continues

～ Tom

October 5

Today the wind is blustery again. The exposed point is windswept most of the time. Even during Indian summer, the air is forceful yet sweet and invigorating, cleansed and filtered by the sea and the nearby evergreen forest.

Our home has nine windows; with seven of them come views of the Atlantic Ocean. I am awed by the stupendous panorama. It is ever so relaxing just to sit and stare out over the blue seas, watching the daily journey of lobsterboats out of Port Clyde Harbor. Watching the creeping tides; watching the birds soar freely; watching the world go around. Watching my world go around. And watching my world go around some more. The wildlife on the point is abundant yet fleeting. In less than a half hour this afternoon, I observe migrating geese, ducks, and cormorants, and a seal. All without getting out of my seat. It is peaceful here, and the wildlife knows it, too.

~ Tom

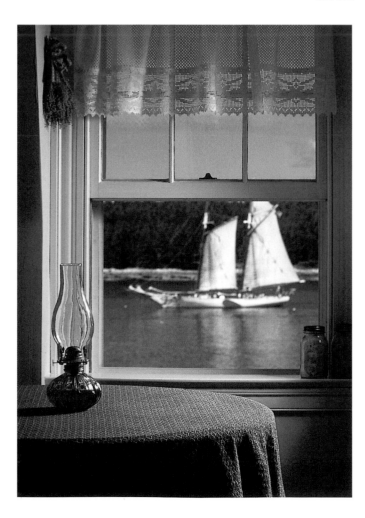

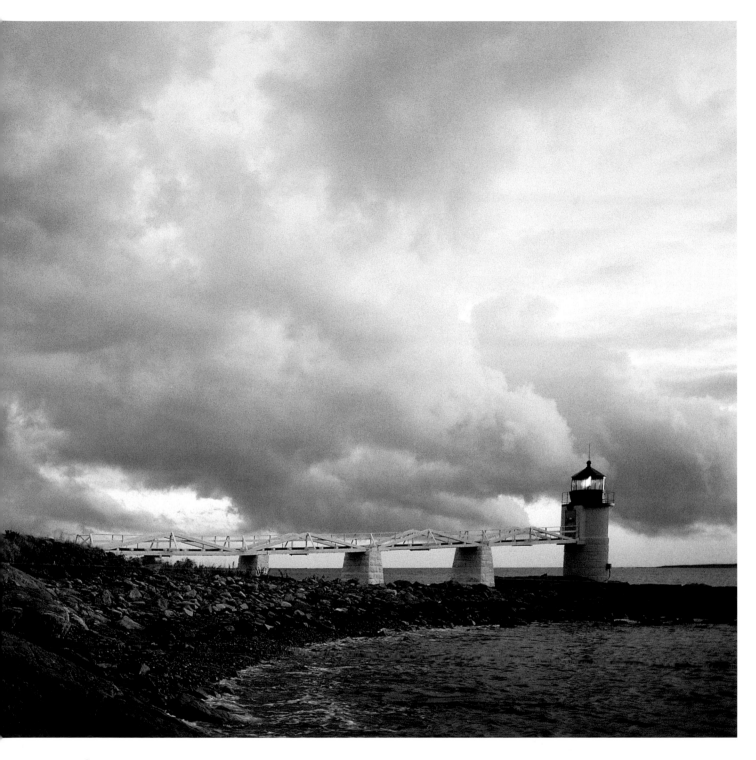

October 28

The sun rises and sets quickly, with the light changing fleetingly. The color shifts are subtle. My discipline as a "painter of the light" elevates my understanding and appreciation of the splendor of Marshall Point. It is my desire to photograph my interpretations of the area in order to preserve and share my emotions, my art, and my life. Others will sense what I experience, if only through my photographs. Only time will tell how successful my intentions will be.

⟶ Tom

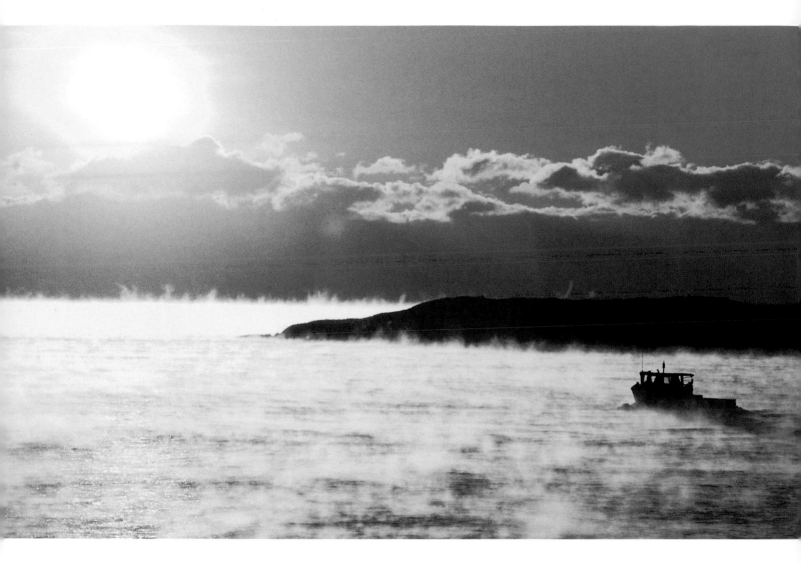

December 2

The temperature at sunrise is minus five degrees Fahrenheit. The frigid air from an "Alberta clipper" lingers over the warmer Atlantic Ocean, forming a layer of swirling vapor over the ocean's surface. Fishing boats appear to fly through clouds in an unearthly, dreamlike realm.

⌒ Tom

December 16

Marshall Point is hammered by the third blizzard of this early winter season. Six inches of snow has already fallen. Winds gusting at over 50 knots rattle the house like an earthquake and form three-foot snowdrifts. Blasts of air whistle through the storm windows. Storm warnings are posted once again for the Gulf of Maine, in what is being described as the worst December weather in fifty years.

⌒ Tom

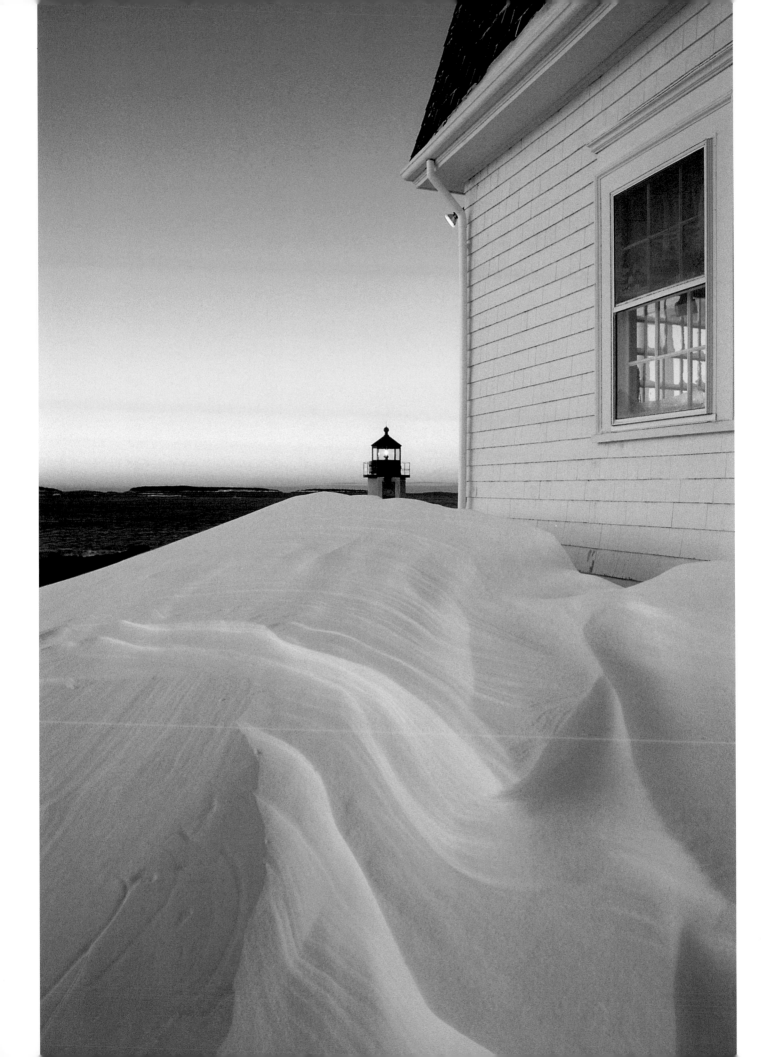

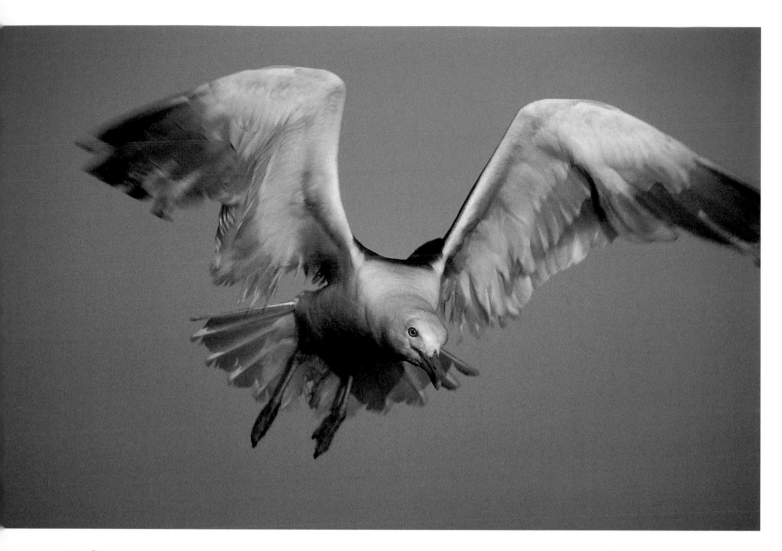

February 28, 1990

The ocean is our theater and the northwest winds are the props. We, the audience, gaze out the kitchen window that frames the best stage on earth. Gulls perform nature's ballet, gliding artistically in the wind.

~ *Tom*

March 10

*T*his past Wednesday evening, the keeper's house was the location for the Marshall Point Lighthouse Museum Committee meeting, the first such meeting ever held at the lighthouse. Not including Lee and me, thirteen people attended the two-hour gathering, the highest attendance for these meetings since their inception. The members seemed enthusiastic about their first visit to our second-floor living quarters.

The meeting was somewhat cozy, with fifteen bodies nestled together in our parlor, mastering the plans for the museum's grand opening this summer.

~Tom

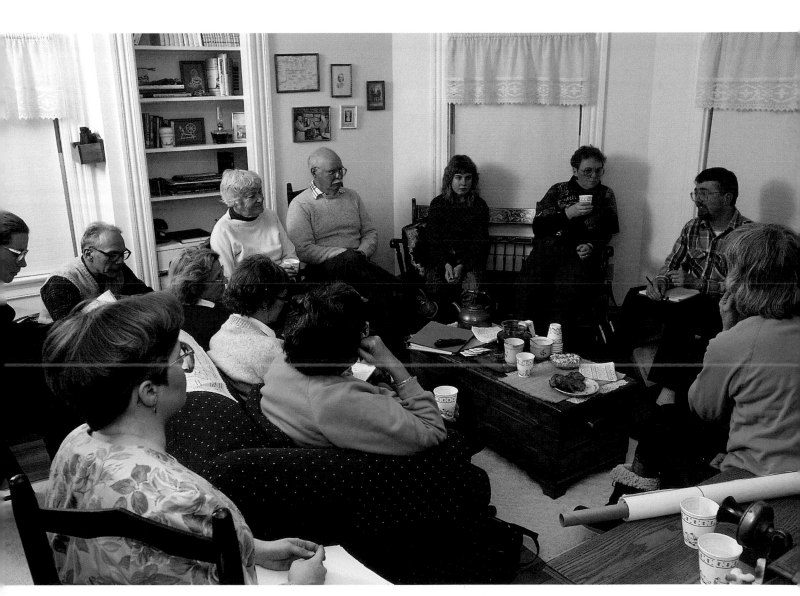

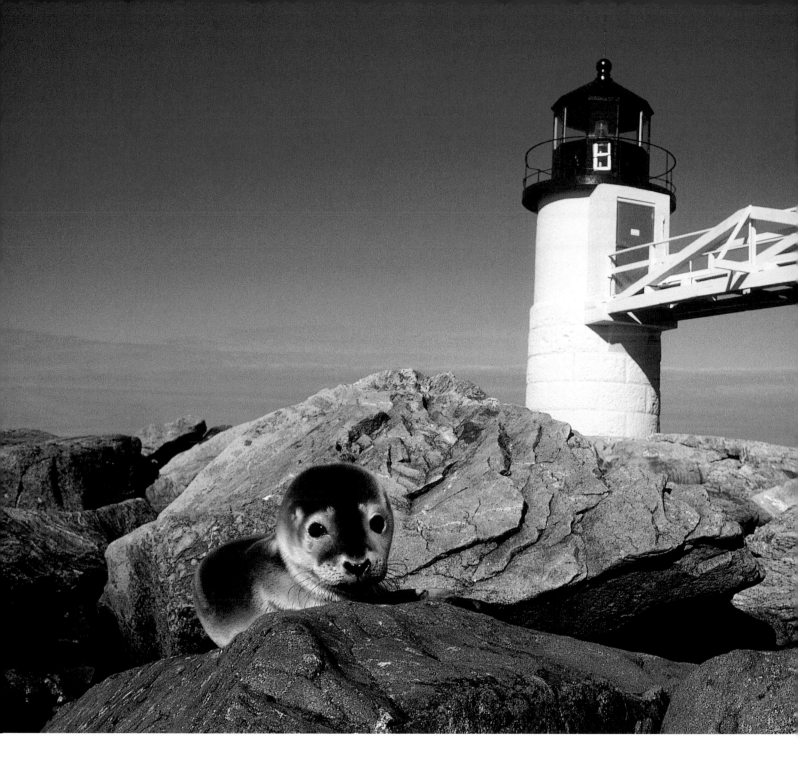

June 3

Reflecting on one of the most amazing experiences in my life, I become very emotional, remembering the attachment and appreciation I'd developed for an abandoned baby harbor seal we named Clyde. Helpless and adorable, he allowed me to observe him all day yesterday as he maneuvered over the rocks, avoiding the ocean water and finally resting in a bed of seaweed. Never before had I seen a seal on land, so his every move, characteristic, and behavior was fascinating. As engaged as we were with him, I believe he was just as curious about Tom and me: he would sniff us, stare at us, and observe our every move.

As the sun began to set, my heart began to melt, knowing Clyde was on the rocks, in the dark, all alone. Wouldn't he be happier in the house with us, where we could keep an eye on him? Of course not. I knew better. We needed to leave him where his mother could find him. At 10 p.m. I sat alone in the parlor, silently concerned about Clyde's well-being. At 8:30 we'd last observed him sleeping peacefully

Clyde was still here. As a result of this phone call, Clyde embarked on a most unusual journey (for a seal, anyway). The aquarium staff made arrangements for Clyde to fly to Boston, where they would care for him at their rehabilitation facility. Now all we had to do was get him to the Knox County Airport, in nearby Owls Head. But how would we transport a seal?

The aquarium experts suggested that we use a laundry basket to carry Clyde. Almost as though he knew we were helping him, he cooperated fully, curling up in the basket and settling in comfortably for the ride. Tom gently placed the basket on my lap in the car, and I stroked Clyde's head all the way to the airport, causing him to fall asleep. It was difficult for me to see him go, and I was worried. What if we weren't doing the right thing? What if we were taking him away from his mother? Tom and I felt as though we had become his surrogate parents, and now we were giving him up. We waved good-bye and shed tears as the plane flew out of sight.

After talking to aquarium staffers later that afternoon, I knew we had made the right decision. Clyde was underweight, only one week old, and weak. I was relieved that he was being cared for now, but I still felt a loss. In just twenty-four hours, I had grown to love, appreciate, and admire this creature. I am grateful for the opportunity to get to know this unique species that shares our front yard, and I think he was grateful to Tom and me for helping him. Each time I look out our bedroom window at the rocks by the light tower, I will always think of Clyde and his big, beautiful eyes; his brilliant, velvetlike fur; and his fascinating webbed flippers.

~ *Lee*

on the rocks several feet above the high-tide mark. We hoped that he'd be gone in the morning—back to his home, his element, his family. I knew he'd be the most beautiful member of his family.

The overnight seemed like an eternity. With the first sign of daylight at 5 a.m., I quickly arose and peered outside to find Clyde in the same spot where we had left him last night.

Following instructions previously given to us by the New England Aquarium, I phoned the staff to report that

June 16

*T*he tide flows in, the tide flows out—along with its companion, the fog, which is so thick you'd swear you could peel it off your body like a garment. The fog feels like a walk through a rainstorm. It quickly saturates clothes, hair, and body.

I met and photographed professional landscape painter Ranulph Bye this morning. He was patiently waiting for the fog to dissipate so he could continue to paint the canvas he started yesterday. He appeared cool and damp, with moisture dripping from his face. I invited him into the keeper's house for a cup of hot coffee.

He was a rather low-key gentleman who was excited and proud of his gallery opening in Camden tomorrow. After a twenty-minute visit, he returned to his painting, still in the fog.

~ Tom

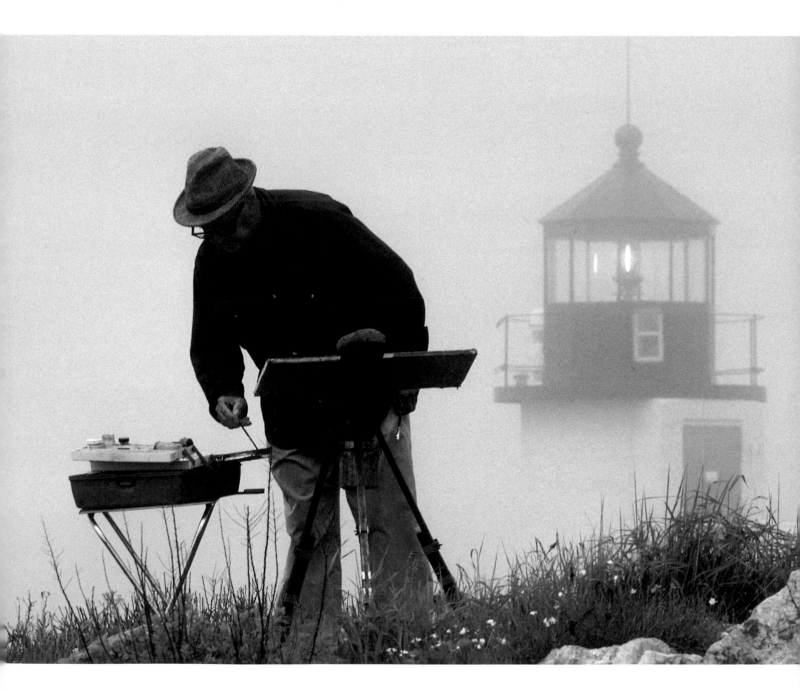

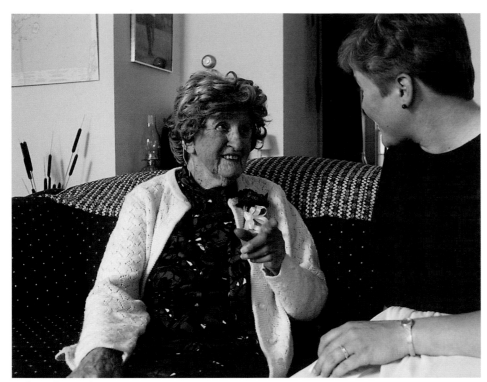

Eula Kelley and Lee

July 1

The official opening of the Marshall Point Lighthouse Museum occurred yesterday with a ribbon-cutting ceremony. Among photographers, reporters, and supporters, the festivities livened up with the arrival of sisters Marion Dalrymple and Eula Kelley, daughters of Charles Skinner, former lightkeeper at Marshall Point.

We warmly welcomed ninety-nine-year-old Eula and ninety-five-year-old Marion into the museum and keeper's house. The onetime residents had the privilege of cutting the ribbon, marking the museum's inauguration.

Marion, who was born in this keeper's house, stood in it once again with her sister, as the guests of honor. I wondered what they were feeling as they returned to the house where they had grown up. Their father, Charles Skinner, was a civilian lightkeeper here for fifty years, the longest service by any lightkeeper in U.S. history.

Camera flashes popped when the sisters signed their names as the first entries in the museum's official guestbook. Lee Ann assisted Marion and Eula to the front of the keeper's house, where a red ribbon, trimmed with red bows, awaited them. The sisters cut the ribbon to laughter and applause, drowning out the roar of the surf. Lee Ann and I were asked to stand beside the sisters for photographs. It was an honor to do so.

Eula was eager to visit her past, and she asked if she might look at our living quarters on the second floor. Aided by Lee Ann, she climbed the stairs with feisty enthusiasm. She pointed out the bedrooms that had been hers, Marion's, and their parents'. This journey into her past clearly moved her, prompting her to mention many tender and emotional memories from her youth. We laughed when Eula said the keeper's house was "as snug as a bug in a rug." She also said, "We had no plumbing, no refrigerator, no nothing."

Eula's half-hour stay was filled with intriguing stories of her life at the keeper's house. Sitting in the parlor, she recalled, with sharp-witted eyes and youthful vigor, that this had been her sickroom when a doctor and two nurses removed her appendix. She told us she had been near death. One nurse later told her it was the worst case of appendicitis she had ever encountered. Lee and I listened intently as Eula described how the local fishermen, motoring near the point, would stop their engines and row their vessels silently to avoid disturbing the ill child.

— *Tom*

July 8

*L*ast evening we lounged on the rocks, waiting for the full moon to rise over the ocean. The motionless waters glistened as far as the eyes could see in the unclouded, pure air. On the far horizon, we could see the lighthouses flashing on Two Bush Island and Monhegan Island. Hundreds, if not thousands, of colorful lobster-trap buoys reflected the rays of the fading sun.

— *Tom*

August 5

A malfunctioning foghorn prompted this morning's visit by two Coast Guardsmen from the Southwest Harbor Coast Guard Station, to make the necessary repairs. The automated horn should only operate during fog, snow, or heavy rain, but today it was blasting under sunny skies and unlimited visibility. The men also cleaned the lens, inspected the bulbs in the lantern, and adjusted the automation system.

— *Tom*

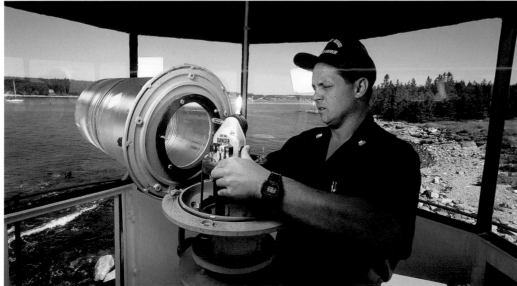

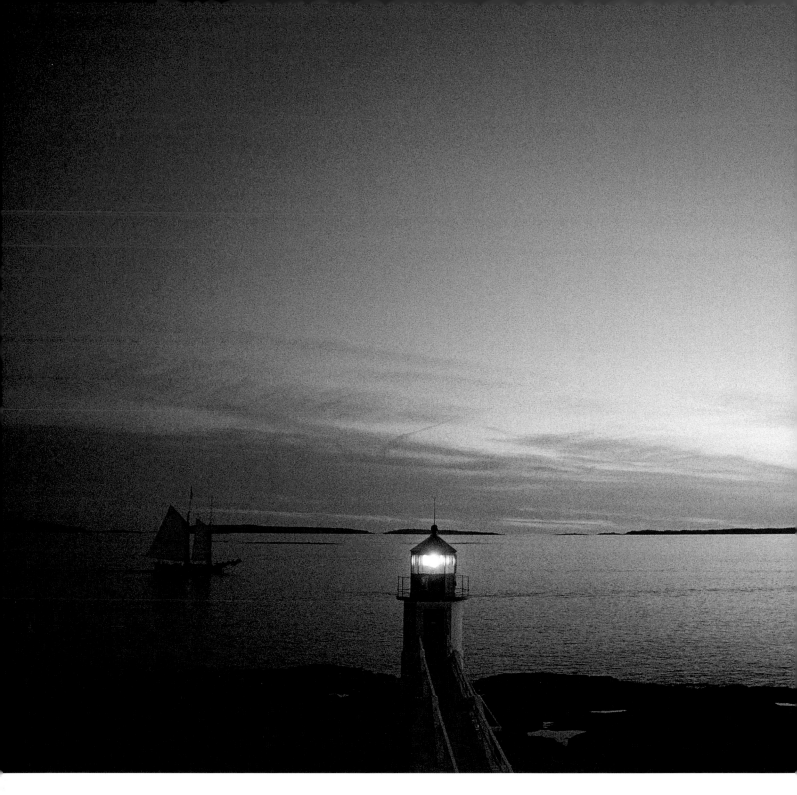

August 20

An early fall–like evening greets three schooners as they sail past the light tower. The tower's beam guides them around the point and into Port Clyde Harbor. The *American Eagle* anchored first, followed an hour later by the *Heritage* and the smaller, but just as elegant, *Wendameen*. Pinks and blues, radiating from the horizon, heighten the romance and nostalgia of these majestic vessels as they quietly glide past the lighthouse.

~ *Tom*

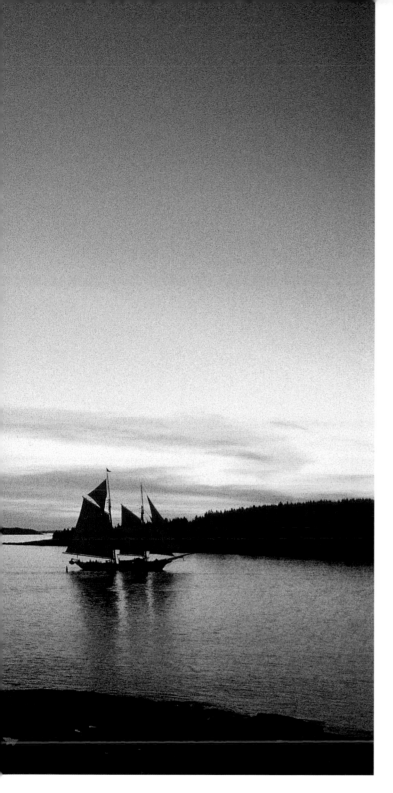

September 9

At nightfall, under a murky sky, a ceremony was performed at low tide in the small inlet we call Stone Cove. Port Clyde Baptist Church minister Ken Parker baptized his son, Ned, in the numbing waters of the Atlantic Ocean.

~ *Tom*

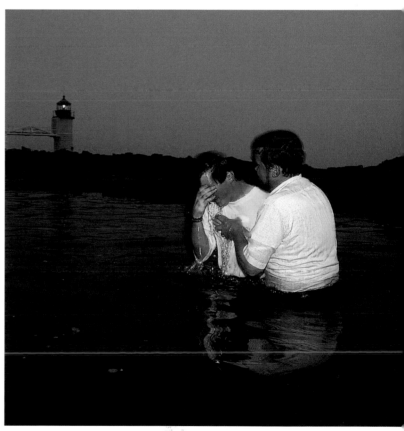

November 23

This journal entry is an excerpt from a letter I wrote to my sister Mary yesterday (Thanksgiving Day).

~ *Tom*

It's Thanksgiving evening and all is quiet on the point. After dining on Cornish game hens we walked along the shore with the crescent moon filtering through the clouds, listening to the eerie cry of a hooting owl. The keeper's house glows with the warmth from over a dozen candles. Our Christmas wreath adorns the light tower, its red bow contrasting vividly against the white structure. Ice and snow will soon cover it.

Earlier we sat on the front steps, absorbing the rays of sun and gorging ourselves with wine, cheese, and crackers. We also enjoyed homemade cranberry sauce made by a neighbor, the wife of a lobster fisherman. We began the day by sitting in bed, eating Marshall Point blueberry coffee cake freshly made by Lee Ann with blueberries she handpicked this past summer behind the keeper's house.

The holiday spirit is blooming. Lee and I searched throughout the five acres of evergreens on the point, looking for our Christmas tree. Next week we'll cut it down and give it a second life.

It's 8:30 p.m. and Lee Ann is playing her piano. The best part of the holiday season is yet to come, and living in the keeper's house makes it even more special and enjoyable.

Happy Thanksgiving,

Love, Tom

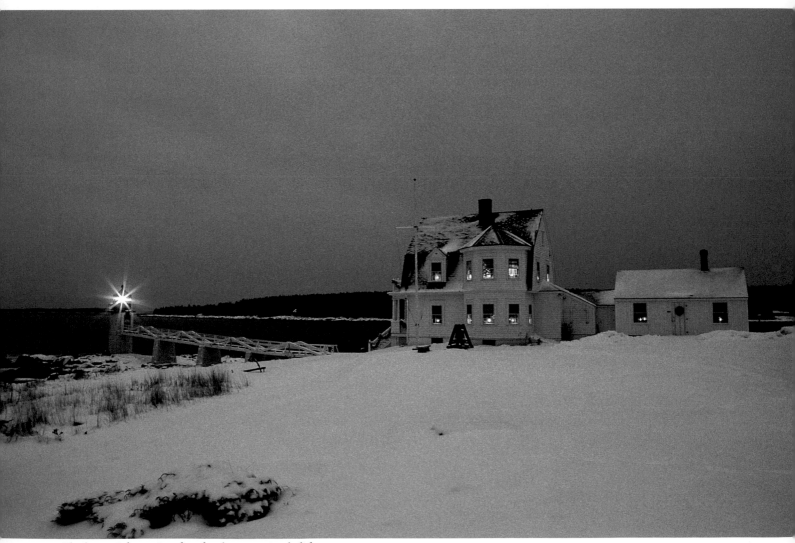

The keeper's house is aglow for the upcoming holiday season.

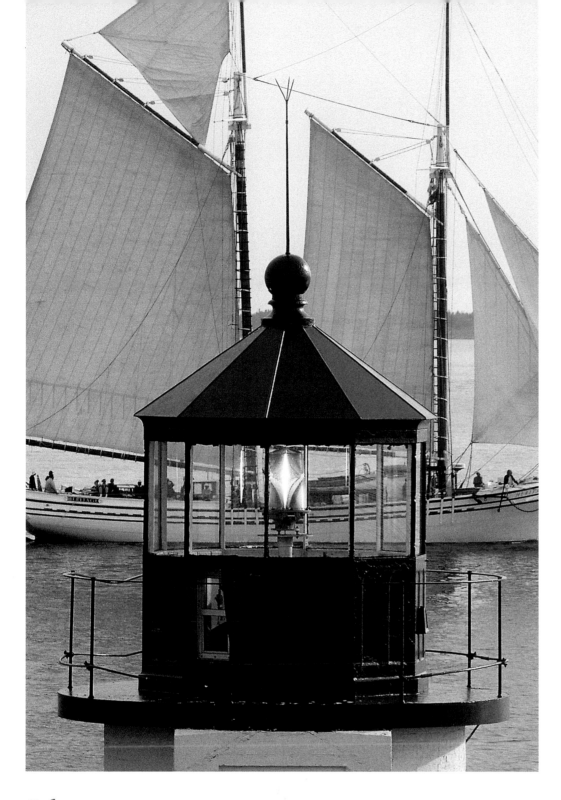

July 21, 1991

Sitting on the front porch of the keeper's house, we enjoy homemade pancakes prepared with blueberries picked moments ago in the backyard—a simple and glorious way to begin the new day.

Tom and I recently visited our neighbors, sisters Marion Dalrymple and Eula Kelley. Marion told Tom that his photograph of the schooner *Heritage* with the lantern room in the foreground was her favorite Marshall Point picture of all time. Quite a compliment coming from a woman who was born in the keeper's house in 1895, lived in the house until 1919, and resides in Port Clyde to this day.

— *Lee*

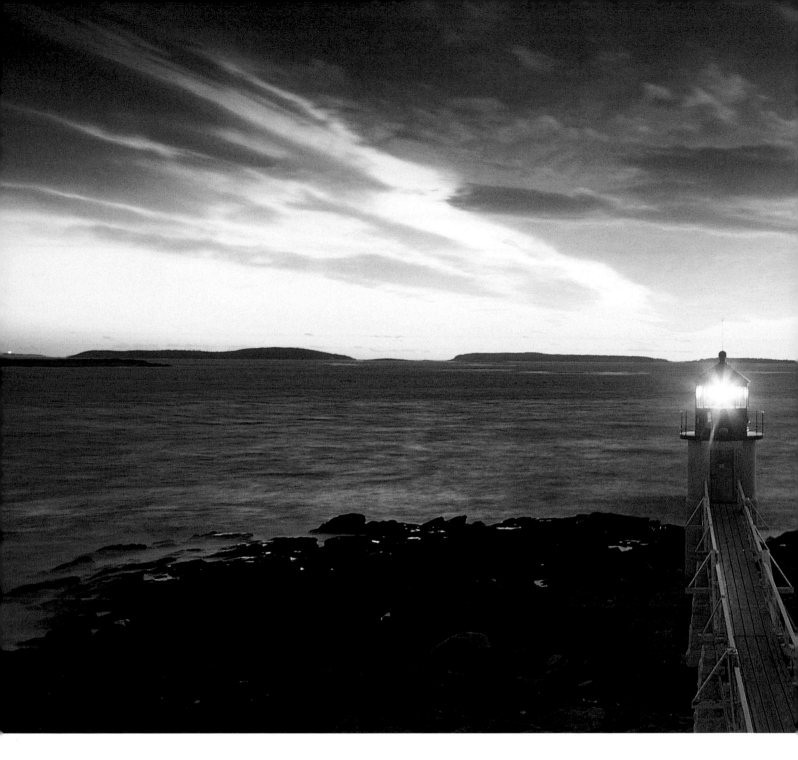

August 24

As I was driving up to the keeper's house at 4:30 p.m. on August 18, an announcement on the car radio captured my attention. The governor had issued an emergency mandate requiring all residents within a quarter-mile of the Maine coast to evacuate. The full force of Hurricane Bob was expected to strike coastal Maine. The storm was coming!

Despite the mandate to evacuate, we were cautiously eager to witness the event from what we hoped would be the security of the keeper's house. Lee Ann quickly prepared dinner while I filled our bathtub with water as an emergency measure. We sat nervously eating our meal, with the rain and winds getting stronger and louder. Suddenly, a vehicle came speeding into our driveway with red warning lights flashing. Seconds later, emergency officials were pounding on our front door, insisting we evacuate to an inland shelter.

Complying, we swiftly gathered pillows, blankets, our two cats, and a board game and said good-bye to the

lighthouse, hoping it would still be here when we returned. Before departing the point, we assisted with the evacuation of Eula Kelley, Marion Dalrymple, and Marion's son and daughter-in-law, Mr. and Mrs. Eugene Dalrymple, from their nearby cottages, while a 40-knot wind and biting rain battered us.

Four hours later, we returned to Marshall Point, finding the keeper's house, footbridge, and light tower still standing. There was no storm damage to the point. The hurricane had lost much of its strength as the eye of the storm passed over Port Clyde. Winds averaging 60 knots—possibly gusting to 90 knots—and two to three inches of rain were all that Bob could generate.

Having survived Hurricane Bob, we were pleased to be home.

~ *Tom*

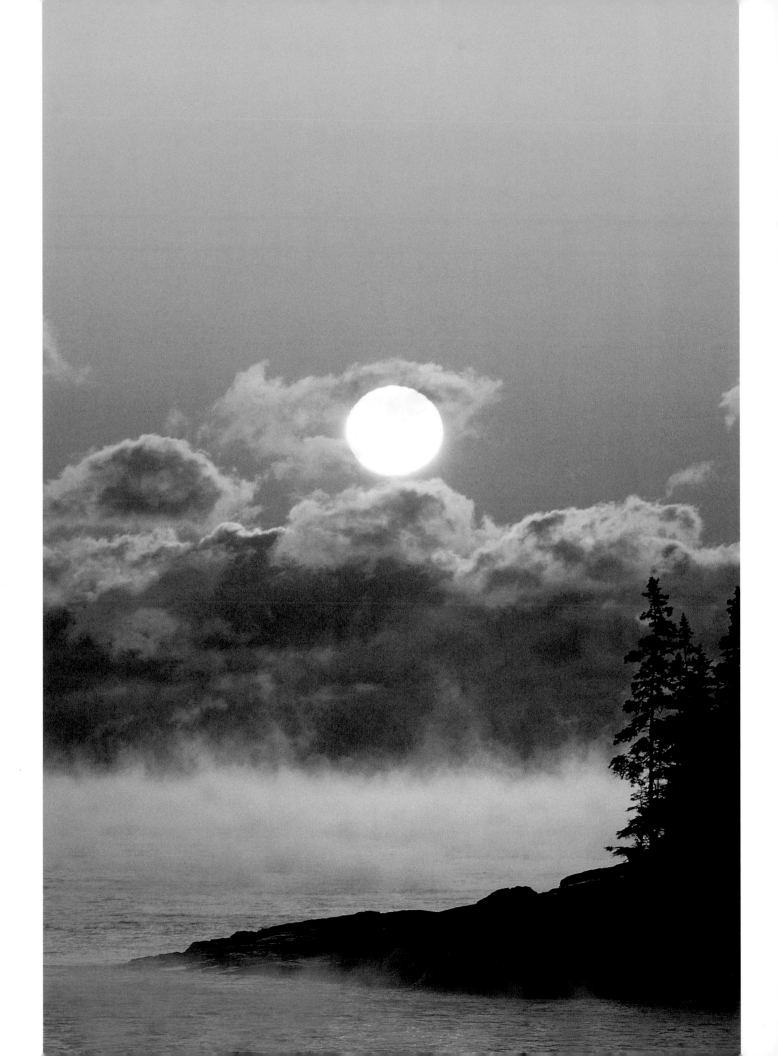

January 17, 1992

Pausing on an ice-covered precipice on nearby Mosquito Head, I see the light radiating from Marshall Point Light, about two miles away, twinkling like a star in the dense, swirling sea vapor. At 6:45 a.m., the air temperature is minus one degree Fahrenheit, with a wind chill of approximately minus twenty-five degrees Fahrenheit. I've come to the head this bitter-cold morning to photograph the rugged and isolated winter landscape. Cold as it may be, I embrace the frigid tranquility.

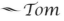

February 17

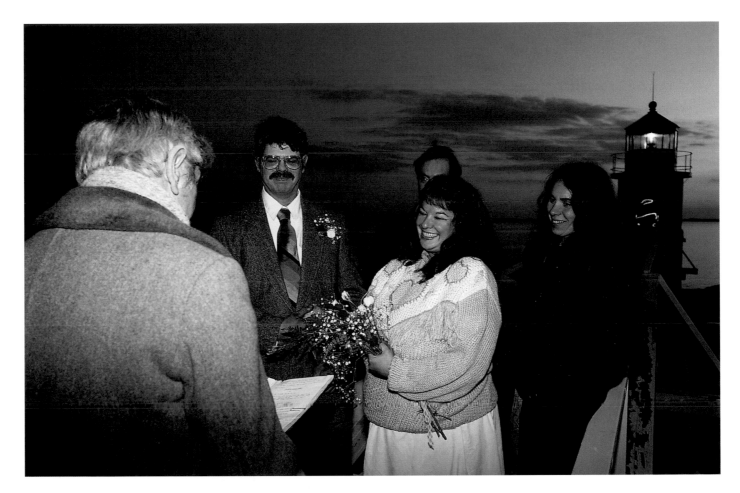

On February 14, we witnessed a romantic Valentine's Day wedding at dusk. A tolerable early winter's evening saw Marilyn Masterson and Adelbert Vinal, both from Tenants Harbor, married in a ten-minute ceremony on the footbridge. The fortunate couple had chosen a rare windless nightfall to wed. Smiles and laughter accompanied the joyful ceremony, and no one suffered from frostbite!

~ Tom

June 3

Paul Dalrymple phoned early this morning with news we had been expecting. His mother, Marion, passed away last night. Paul asked if we would fly the flag at half-mast. I wept, recalling Marion's place in the history of Marshall Point. Tom and I respectfully lowered the flag to half-mast in tribute to her. As the light at Marshall Point endures, so will the memory of Marion Dalrymple.

⌐Lee

October 4

Sunset was somber this evening. Frank E. Clark of Belfast, Maine, laid to rest his recently deceased wife by scattering her cremated remains into the ever-changing tides of life and death.

Frank arrived, respectfully dressed in a brown suit and tie, carrying a small blue box. Inside was a plastic bag containing his wife's ashes. His gray beard was neatly trimmed like those of seafaring captains in a bygone era.

Frank opened the plastic bag and quietly poured the ashes into the ocean. The fine dust turned the water gray for several seconds, before the tide dispersed it. Although the event was over in seconds, and Alison Clark's ashes dissipated in the water, her memory will forever fill our hearts.

~ Tom

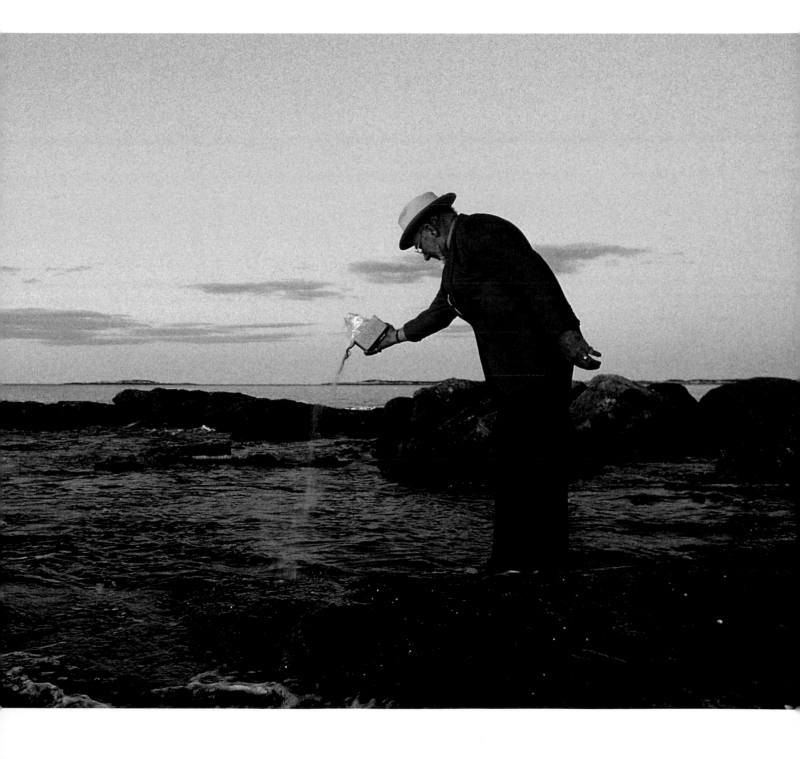

January 31, 1993

I don't remember a day colder than this one. The temperature is minus 11 degrees Fahrenheit, and it is snowing briskly. Every window is glazed in a layer of ice, etching bouquets of frosty flowers and leaves. We are so anxious to watch the snow that we use a hair dryer to melt the ice off the windows.

~ *Lee*

February 7

T he hushed air has its origin in the Arctic. The frozen timbers on the footbridge crack from my weight, sending an echo up Herring Gut ("the Gut" to locals). Smoke swirls from our chimney and dense sea vapor billows from the ocean surface. The minus-nine–degree temperature is ominous.

A scallop dragger cautiously navigates past the light tower and vanishes in the vapor. The spindly boom is the last

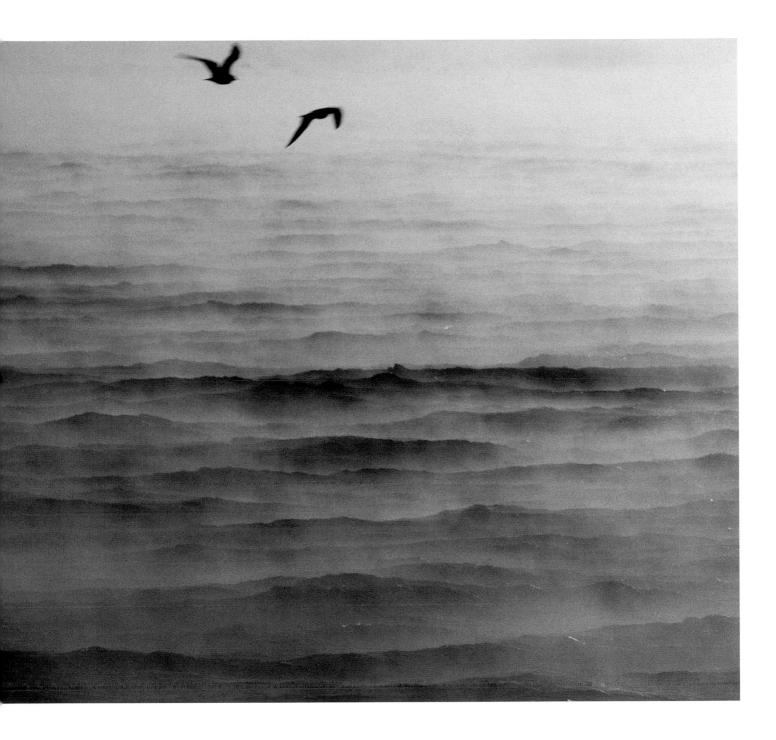

I see of the vessel as the frigid, fireless sea smoke engulfs it. The vapor shines golden from the rising sun. Long-tailed ducks fly with limited visibility.

I'm kept warm by two pairs of wool socks, a wool union suit, cotton T-shirt, wool flannel shirt, wool sweater, scarf, down coat, two pairs of gloves, and a heavily insulated hat that I purchased in the former Soviet Union.

It's now 10:15 a.m. I've been inside the keeper's house for fifteen minutes, yet my bones still shiver from the four hours I spent outside creating photographs. Soon I will take a hot shower. It's the only thing, besides Lee Ann, that will warm me.

⏤ Tom

June 26

At 5:45 a.m., we paddle by kayak to a small island located in our front yard, the Atlantic Ocean. En route to nearby Hart Island to photograph nesting seabirds, my kayak is severely top-heavy with a waterproof camera case. Fortunately, the placid waters make for a tranquil journey.

On the low-lying island, herring gull eggs are hatching profusely. We behold the beginning of life when a newborn gull uses its egg tooth to crack open its shell. It is extraordinary to witness these births in vast abundance. There may be several hundred herring gull nests on the island, each containing one to three eggs. Offshore to the south of the island, a thousand common eider ducks sway in an immense, tight raft.

Hart Island is uninhabited and seldom visited by man. Driftwood, trash, shells, lobster buoys, and lobster traps are among the flotsam and jetsam accumulating along its shore. Nearing the distant edge of the island, we encounter a bizarre scene. Above the high-tide mark we notice unusual movement within a derelict lobster trap. Inside the trap are three adult female common eiders, hopelessly stuck.

The birds thrash wildly as we approach and struggle to open the mangled trap. Successfully releasing two of the birds, we watch them fly safely away. Rescuing the third duck will not be so easy. One of its wings had become entangled in twine, preventing us from freeing the helpless bird. We hunt for a shard of glass among the debris. During a fruitless ten-minute search, we only find plastic bottles. Desperately, we use a sharp edge from a broken seashell and successfully cut the twine, unraveling it from the eider's wing. Grasping the bird with care, I examine the wing. Finding no injuries, I release my grip, and it flies toward the center of the island into dense vegetation. With the exception of a few damaged wing feathers, the bird seems strong and healthy. The poor creatures were doomed to slow starvation if it were not for this fateful encounter.

~ *Tom*

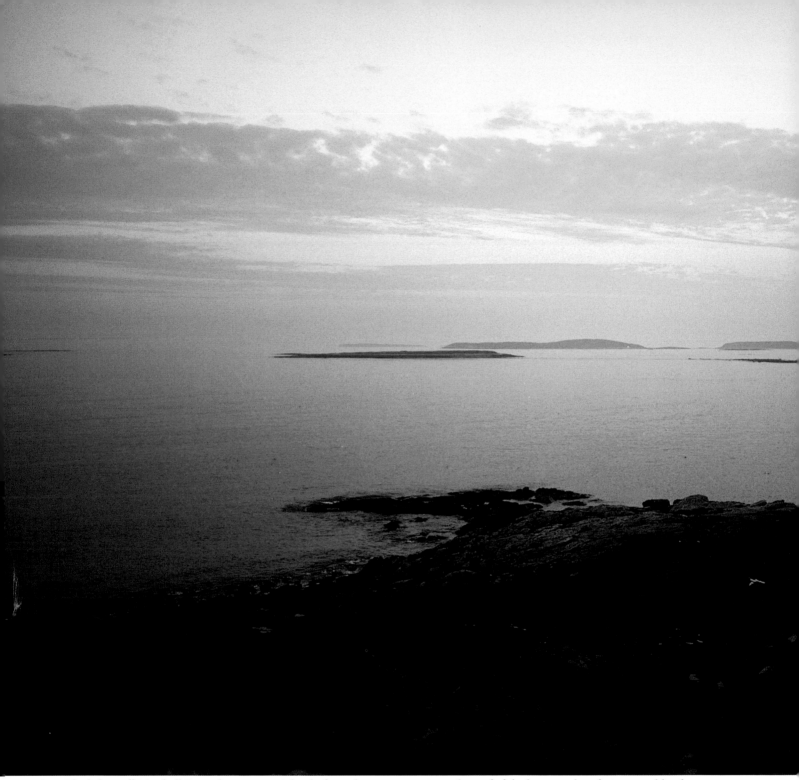

The ledges off Marshall Point show up more clearly from this vantage point—the roof of the house—than from ground level.

July 12

Two nights ago, while trying to sleep, I relived dozens of times a near-disastrous mishap. During the chaos of the incident, I had remained calm and cool. Hours afterward, in the quiet of my bed with everyone safe and sound, I had an anxiety attack. I was tense and nervous and my stomach was twisting.

I had invited my visiting sister Betty on a kayak excursion. Aware that she had minimal kayaking experience, I made sure we initially stayed close to the lighthouse and the shoreline. The air was hot and the seas were still. Betty was paddling with confidence and strength, so I suggested we navigate farther offshore toward the Gunning Rocks Ledge. I glanced at

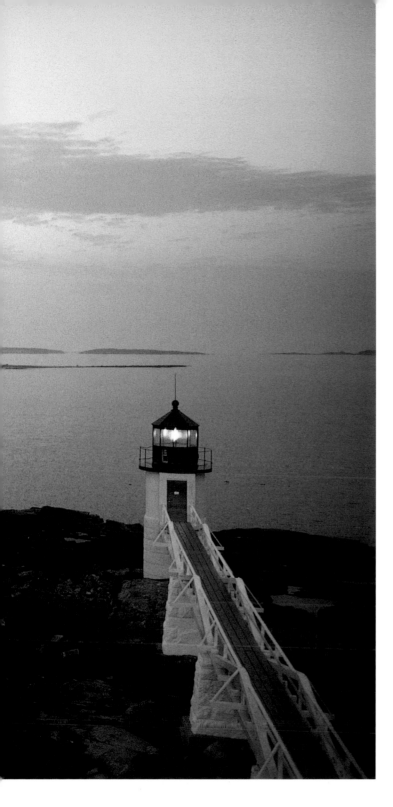

helplessly. Her breathing was short and quick. She was frightened and near panic, and I had to calm her. In a comforting voice, I reassured her that everything would be fine. I knew that she would be okay—albeit wet, perhaps cold, and definitely embarrassed.

I advised her to take slow, deep breaths, and she began to relax. Then I gave her instructions on how to get back into her boat. The first step was to right the kayak. Surprisingly, we succeeded on our first attempt. Betty said she was getting cold. I urged her to remain calm because the next step would be difficult. She would need to exert a tremendous amount of energy to pull herself into the kayak, and a failed first attempt could leave her without the strength for a second try. She was unsuccessful in her first try. With fear in her voice, she said she didn't have the energy for a second attempt. I reassured her that we would get her back into the kayak. Once more I reviewed the self-rescue technique, and with a tremendous effort that left her legs bruised, she successfully climbed back in.

Although there was a sense of relief, Betty was still scared and uncertain, drained of the confidence she had displayed when we began the journey. I was determined that some good was going to come out of this near-disaster. If Betty had the strength and courage to paddle back, it would only build her self-esteem. With coaching, she did paddle back on her own.

Back in the keeper's house, we discussed the experience. We were safe, so the joking could now begin. I told Betty that the granola bars in her kayak were not for human consumption, but rather for feeding to the sharks so they wouldn't eat her.

～*Tom*

the keeper's house and waved to my mother and Lee Ann, who were watching us from the second-floor porch a quarter-mile away. Suddenly, and without warning, Betty screamed my name as her kayak flipped on its side and she went into the water.

I could detect the terror in Betty's eyes as she floated

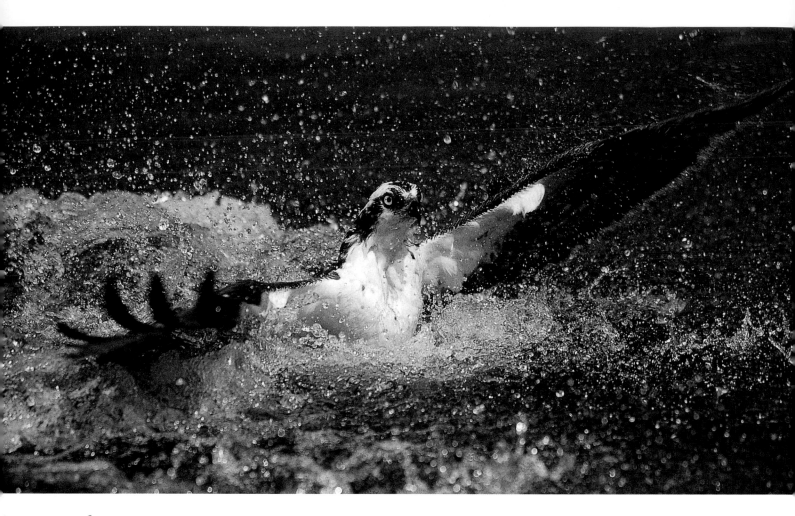

July 19

An osprey is on the prowl again at dusk. As it soars high over Penobscot Bay, its eyes gaze downward, searching for prey. A harbor seal swims past the point, feasting on the same schooling fish that have attracted the osprey. With extraordinary mobility and grace, the osprey tucks its pointed wings to its sides and plunges feet first into the dark ocean. The water erupts.

The osprey floats, motionless, for a few seconds. Only its black-and-white head appears above the surface. A fish, captured in the osprey's razor-sharp talons, battles for its life. The osprey struggles with the fish, rises from the water with its slippery meal, and then heads back to its nest to feed the young.

— *Tom*

September 4

Fog. From Marshall Point to Mount Desert Rock, the coast of Maine cannot escape the inevitable.

The foghorn bellows twice every thirty seconds. The vibrant shaft of light emanating from the light tower rotates around the glass-enclosed lantern room.

I'm not at Marshall Point today. I'm on Mount Desert Rock, site of the most isolated lighthouse on the Maine coast. It's a tiny spit of land, twenty-five miles from the mainland. This is my second day on the barren rock. Yesterday, I hitched a ride on a Coast Guard boat to the islet to spend five days photographing the lighthouse and the researchers from College of the Atlantic's Allied Whale program who are stationed here.

The researchers wait for the fog to lift, dancing the night away and playing billiards. Only when the fog lifts can they scan the waters for whales, working two-hour shifts atop the light tower with binoculars and two-way radios.

— *Tom*

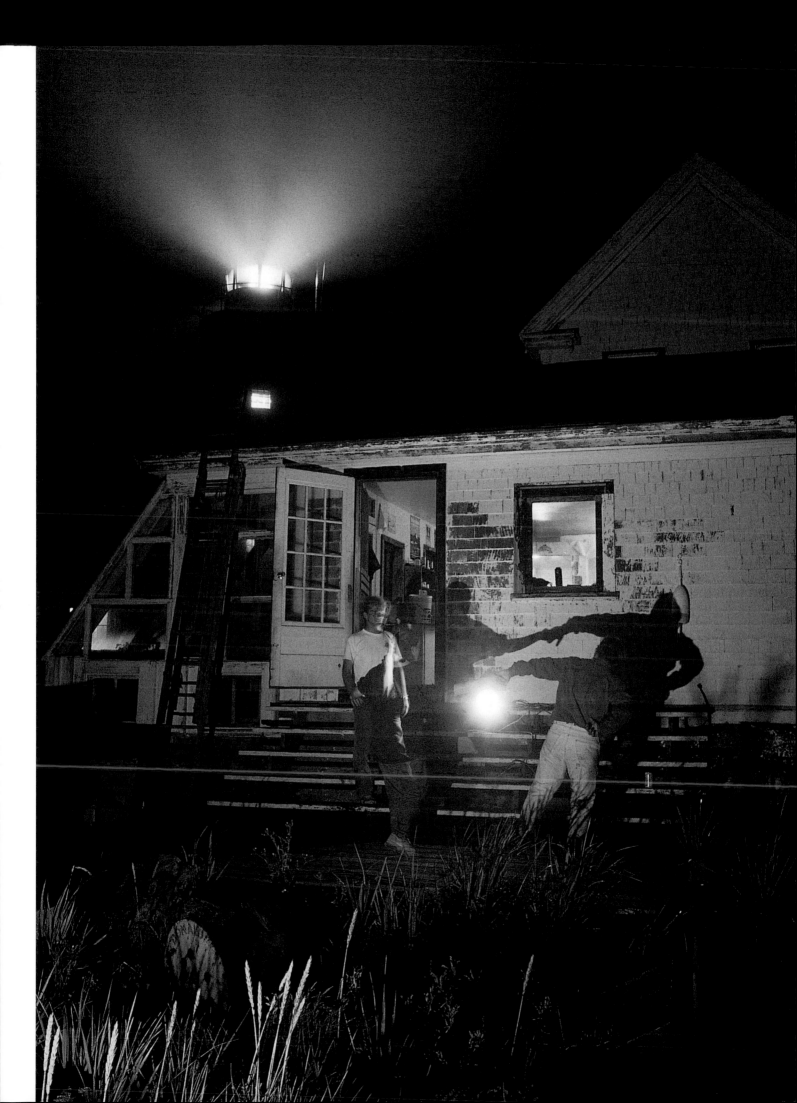

January 27, 1994

Massive ice boulders, some weighing perhaps as much as five hundred pounds, surround the point, floating during high tide and then settling on the rocks at low tide. The tide pools are frozen solid. A layer of ice glazes the shoreline. Dozens of common eider ducks swim around the point, oblivious to the numbing air and water. Oh, to be clothed in eiderdown!

~ Tom

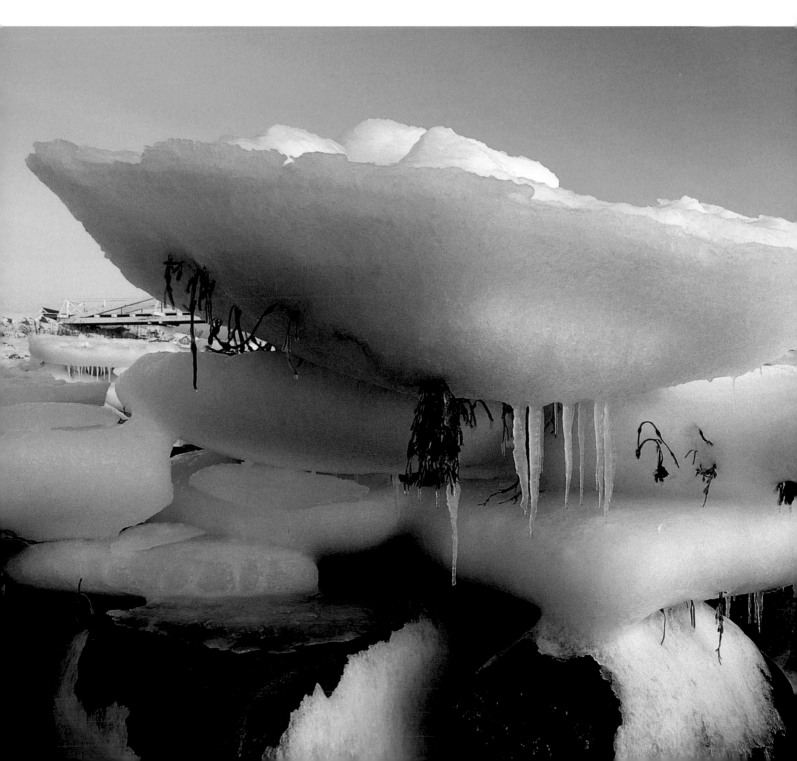

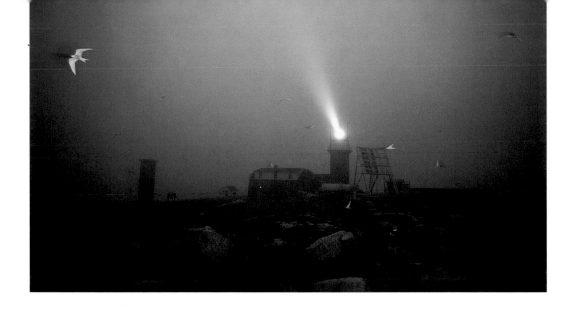

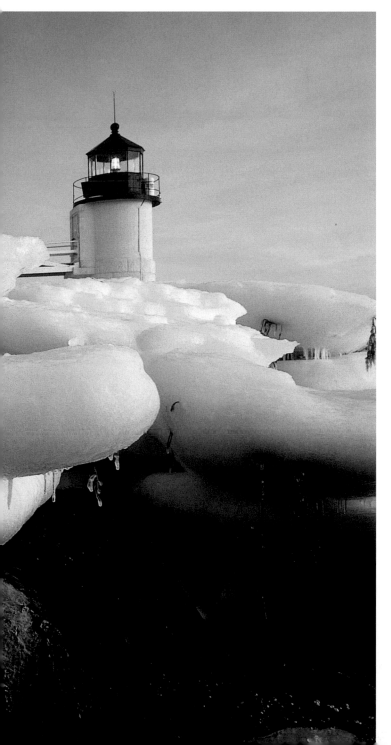

June 14

*T*oday is our first full day on Matinicus Rock. Blustery, dripping, foggy air shrouds the entire island. This is not the weather we hoped for, but it is certainly typical of this isolated place. I write this journal entry while crammed in a tiny burlap observation blind, which is normally reserved for bird researchers studying the nesting colonies of puffins, terns, murres, and petrels. Tom and I are using the blind to photograph the birds without disturbing them.

After three hours crouched in the blind and battered by a harsh, damp, steady wind, we seek relief in the light tower. I sit on a wooden bench built along the perimeter of a round room located immediately below the lantern room. Striking wood paneling covers the walls and ceiling, and an undersize door allows passage to an exterior catwalk. Leading to this room is an ornate iron spiral staircase consisting of thirty-three steps.

Matinicus Rock lies only about twenty-three miles from Marshall Point, yet it is so unlike the point in its rugged ecological splendor and remoteness.

⌐ Lee

June 21

We recently went to the Forest Hill Cemetery, in nearby South Thomaston, to visit the grave of Abbie Burgess, who gained fame as a keeper at Matinicus Rock Light. At only fourteen years of age, Abbie singlehandedly tended the lights in the two towers one winter when her father, keeper Samuel Burgess, had to sail to the mainland for supplies and was unable to get back to the island for four weeks. I have always found her courage inspirational. Through harrowing storms and near starvation, she not only kept the lights burning, but saved her family from being drowned when their quarters were swept away during one particularly severe storm.

Our poignant visit to her grave was on the 102nd anniversary of her death. We had just returned from a three-day stay on Matinicus Rock to photograph the lighthouse and the island's seabird nesting colonies. We ate breakfast in the keeper's house where Abbie cooked for her family. We climbed the spiral staircase to eat dinner in the light tower, where the Burgess family took shelter from a stupendous storm in 1856, when the sea engulfed the entire island.

~ Tom

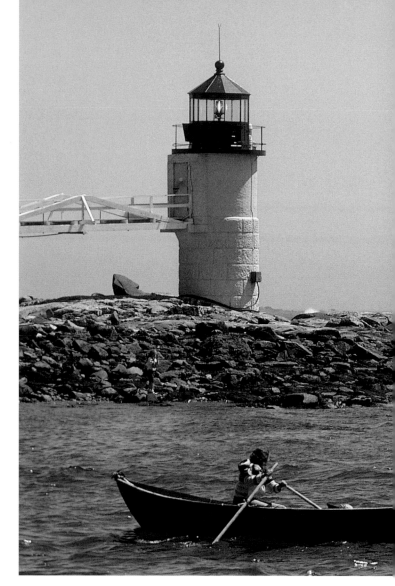

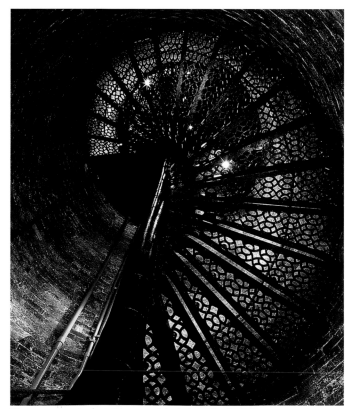

The ornate spiral staircase at Matinicus Rock Light

July 3

Two days ago, while working in my office, I noticed several sightseers photographing the ocean and peering through binocular, as visitors to Marshall Point commonly do. These folks were looking toward nearby Hupper Island. This was unusual, because most people stare southward toward the open sea and the light tower. Nevertheless, I continued to work at my desk. After several minutes, I again glanced out the window, and I noticed that the tourists were still gawking toward Hupper Island.

Going to a kitchen window to see what was attracting so much attention, I was startled to see a large two-masted sailboat rapidly approaching the piercing reef that projects from the west side of the point. It took only a few seconds before I realized that the vessel was out of control, and the wind and surf were hurtling it toward the submerged rocks. Then the boat slammed into the ledge. Throngs of bystanders lined the shoreline, watching as the precarious situation evolved.

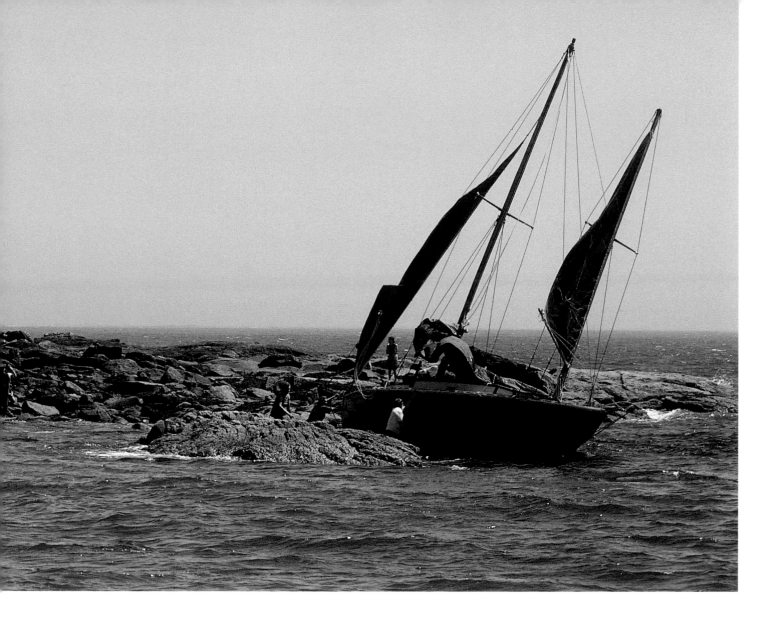

The *Isabella*—a thirty-two-foot wooden Lockeport ketch, built in 1978 in Lockeport, Nova Scotia—was snared on the ledge, rolling violently in the wind and surf.

The captain of the ketch *Isabella* got his wife and daughter into a dory and set them afloat. Although the woman appeared inexperienced as she rowed the dory, she successfully maneuvered it to the cobblestone beach in Stone Cove, where she and her daughter got out unharmed. Only her husband remained aboard the distressed ketch as the incoming surf continued to batter the boat. Finally he lowered the sails from the two towering masts—a step he should have taken earlier. The wind had gripped the sails, intensifying the mishap.

Several bystanders had waded chest-deep toward the ledge in the numbing water and were attempting to manually dislodge the boat from the ledge. I realized immediately that these people were placing themselves in a treacherous situation. What had begun as a simple grounding could easily turn into a tragedy. I thought of shouting to them to get out of the water and away from the boat.

I wish I had. One man, who was unsteadily balanced on the slick, algae-covered rocks, was shoving the boat. Suddenly he slid on the rocks and tumbled into the water just as a forceful swell picked up the boat and sent it toward the ledge. As the Good Samaritan struggled in the water between the ledge and the massive boat, it appeared that he was going to be crushed to death. Frightened screams echoed across the point. One woman shrieked in absolute terror: "What the hell does he think he's doing?" Miraculously, a split-second before the boat crashed against the rocks, the man crawled to safety —only a moment away from certain death.

~ *Tom*

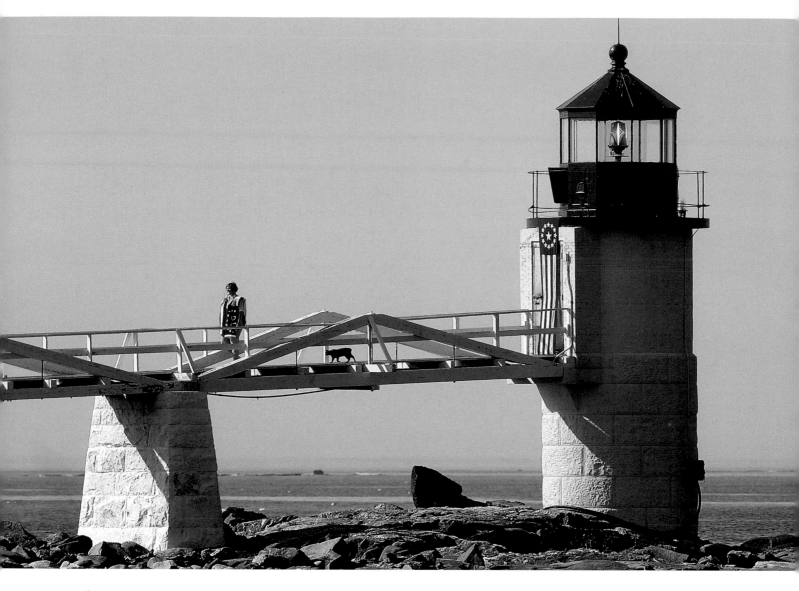

July 5

This Fourth of July weekend we hung our distinctive holiday flags. We hoisted Betsy Ross, Bennington, and United States flags up the flagpole. Two twelve-foot colonial banners were hung: one from the light tower and the other from a second-floor window of the keeper's house. A sleek, tailless, gray cat—of unknown origin—befriended us while we raised the flags and banners.

When we were returning to the point in our kayaks today, we heard two musicians playing a guitar and a violin on the rocks near the northern reaches of Stone Cove. The amateur musicians were on vacation and just "hanging out at the point."

~ *Tom*

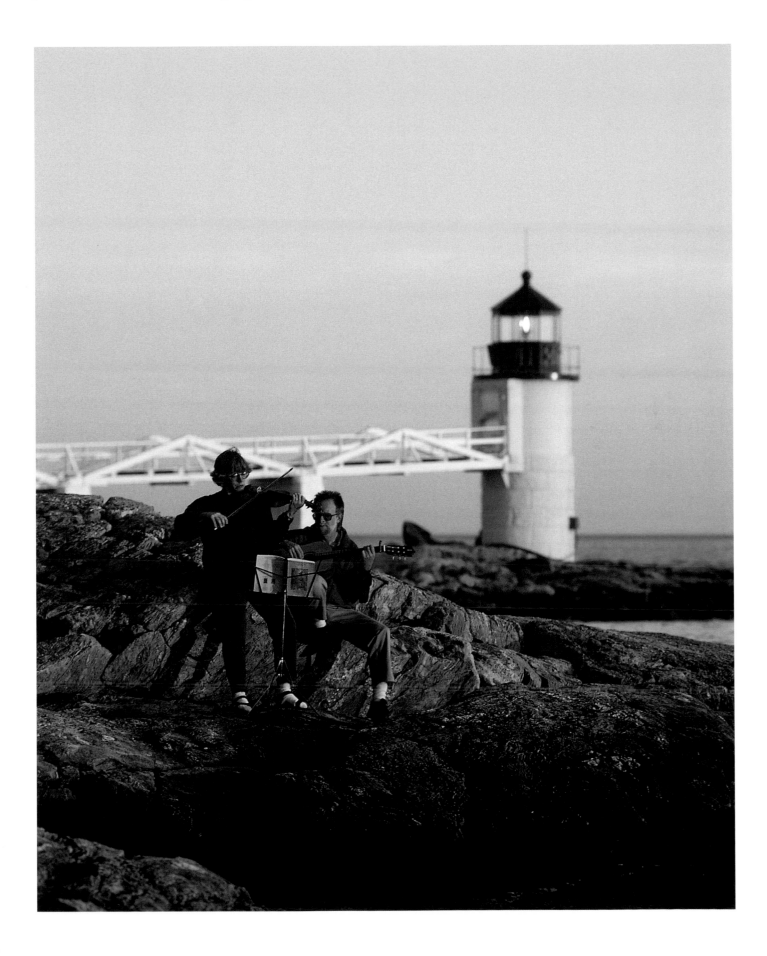

August 8

Two days ago an intimate group congregated near the shoreline to witness the baptism of Mark Winston Lunt, the one-year-old son of Nancy and Donald Lunt of Tenants Harbor. Retired Methodist minister David Campbell baptized the child, using a bowl of sea water scooped from Stone Cove by the child's mother.

When I asked Nancy why they decided to have the christening at Marshall Point, she replied, "We both like it here. Don wanted him baptized in the ocean, and I wanted him baptized in the river." They compromised by holding the ceremony where the St. George River meets the sea.

⌐ Tom

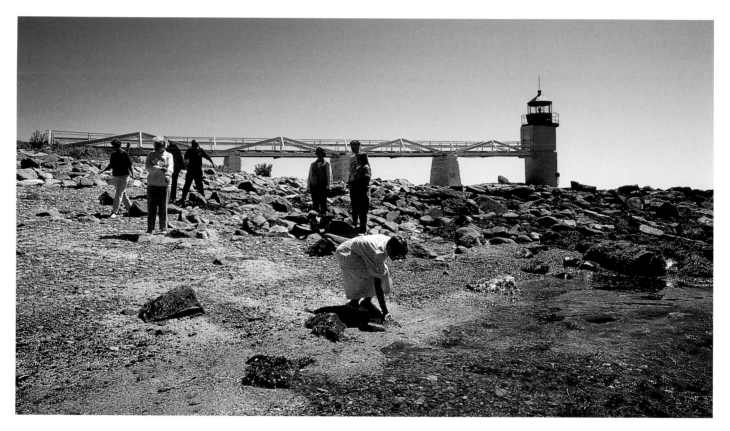

August 29

A major benefit of residing only thirty feet from the ocean is the ability to launch our kayaks in less than five minutes. Yesterday morning we chose this mode of transport for picking up supplies in the village.

Approaching the inner harbor, we found ourselves in a maze of moored fishing boats. A black-crowned night heron fished near a dock. A harbor seal played hide-and-seek with us among the boats. We landed ashore and headed into the Port Clyde General Store for groceries and the Sunday papers.

⌐ Tom

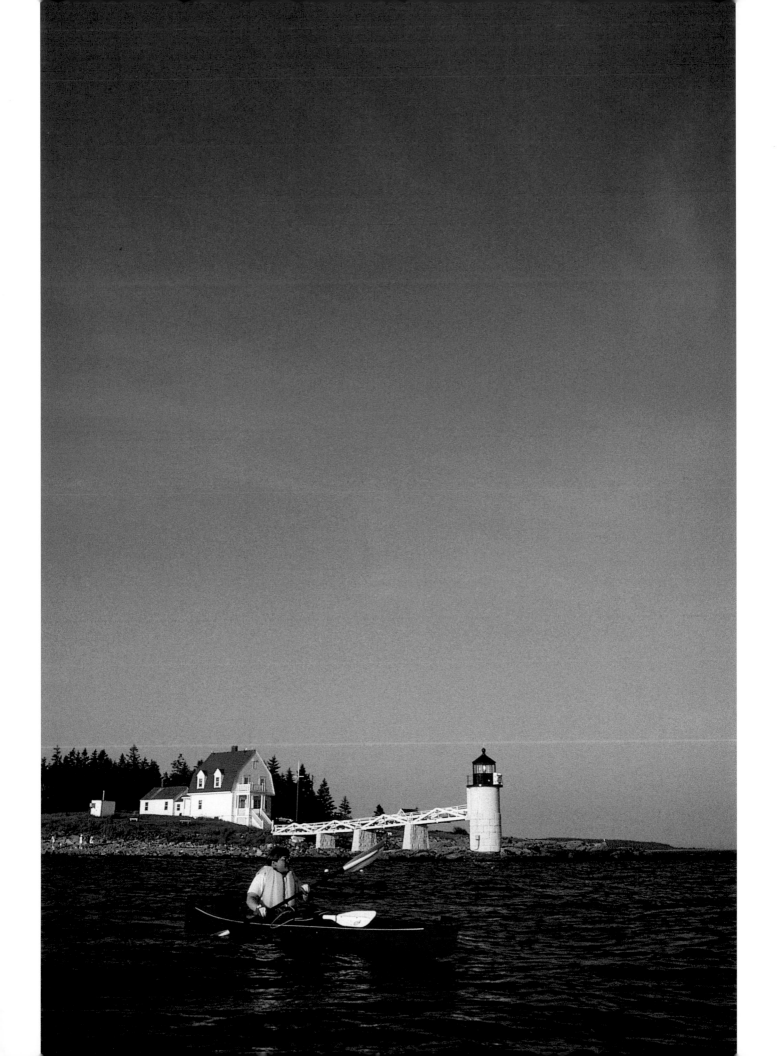

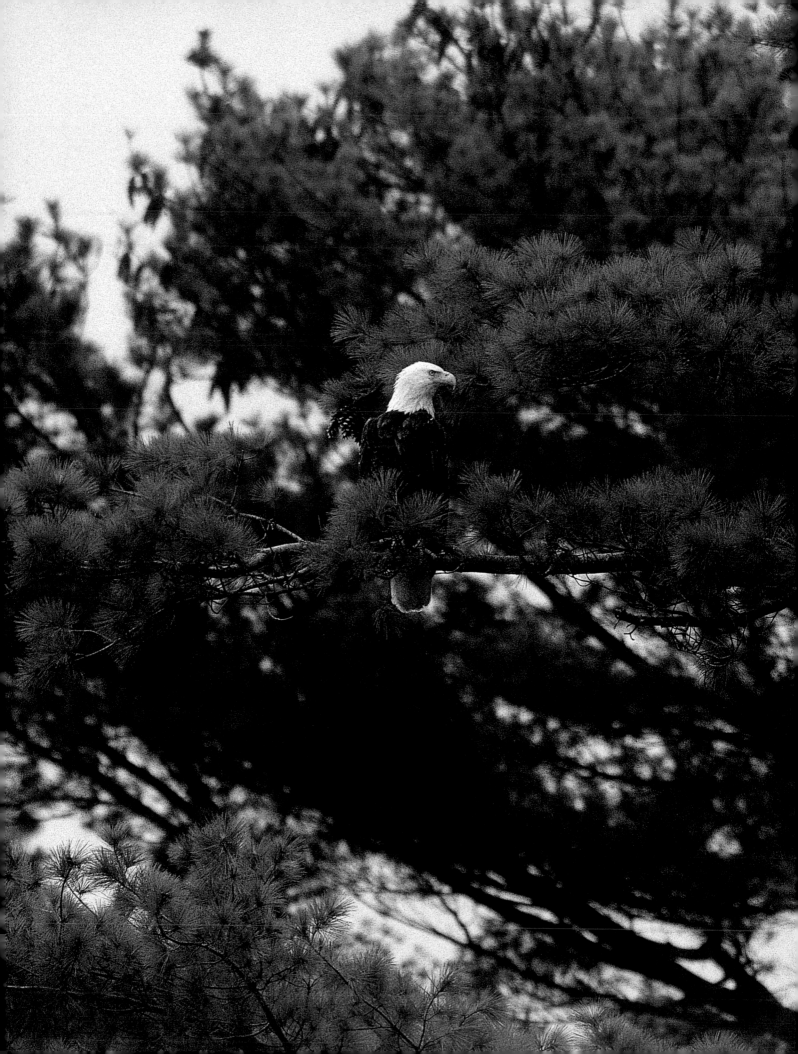

December 15

For nearly two hours I've been witnessing a life-and-death struggle. The drama began while I was sitting on our couch in the parlor, using our 10-power binoculars to search for gray seals on Gunning Rocks Ledge. Suddenly I spotted an adult bald eagle, its telltale white head and tail reflecting the setting sun.

Gliding low in a tight circle over the ocean, the eagle began to dive repeatedly toward the surface of the sea, attempting to catch a male common eider duck. With each of the eagle's dramatic dives, the eider would submerge to escape. When the duck surfaced to catch its breath, the eagle immediately swooped toward it, forcing the eider to submerge again and again in its effort to escape. This relentless assault continued for at least half an hour.

The eagle's hunting technique was working. The eider became exhausted, allowing the eagle to grab it and begin flying the seventy-five feet to Gunning Rocks Ledge. The eagle struggled with its prey, weighed down and barely staying aloft. Twenty-five feet from the ledge, it crash-landed in the ocean, trying to stay above the surface as it used its wings, in vain, to swim toward the ledge. I was concerned that it would drown or succumb to exposure. After five minutes in the cold water, the eagle leaped out and flew to the ledge. It was safe, and the eider had escaped—or so it seemed.

After a ten-minute rest, the eagle renewed its assault on the duck, which I suspect had been injured in the first attack. The eider tried again to escape by submerging three times before it became exhausted. In one final display of power, the eagle rocketed toward the eider, its deadly talons making a direct hit. The impact sent the eider tumbling end over end in a deathblow. The eagle returned to retrieve the eider, plucking it from the water and attempting to fly with it to the ledge, now only fifty feet away. Again, it lacked the strength to carry its large prey. Dropping the duck into the sea, the eagle flew on to the ledge, landing on a boulder to rest.

Ten more minutes elapsed before the eagle tried again to retrieve its catch. This time, it was met by an immature eagle that was trying to steal the duck. The intruder flew down but failed to grab the eider. The two eagles battled for ten minutes, with the immature bird finally winning and chasing away the adult. The adult eagle disappeared behind Mosquito Island.

When the younger eagle returned to get its prize, it, too, lacked the strength to carry the heavy duck, and it plummeted into the sea. After floating for several minutes, the eagle erupted from the water, without the eider, and landed on the ledge.

A second immature eagle arrived and landed nearby. Minutes later, the adult eagle returned. By then, darkness was fast approaching. The silhouettes of the three eagles flying toward their roosts on Hupper Island provided my final glimpse of them.

They had succeeded in killing their prey, but even two eagles could not carry the eider to the shoreline. The birds will sleep with empty stomachs tonight.

— Tom

January 15, 1995

I performed the duty of washing the windows of the lantern room in the light tower. Next to keeping the light illuminated, one of the most important functions of a lightkeeper is keeping the glass panes of the lantern room clean, so the light can radiate seaward unimpeded. As I balanced on the catwalk to polish the windows, gale winds howled mercilessly through my frigid hands.

⌐Lee

January 17

Y esterday was a restless day. A surprise inspection by United States Coast Guard Chief Thomas Dutton left us nervous and exhausted. We were kept busy cleaning the light tower and the keeper's house. Tom's unexpected visit gave us a taste of what lightkeepers of old may have experienced when they were subjected to unannounced scrutiny of their homes.

The surprise inspections must have given the lightkeepers considerable stress and displeasure. They certainly

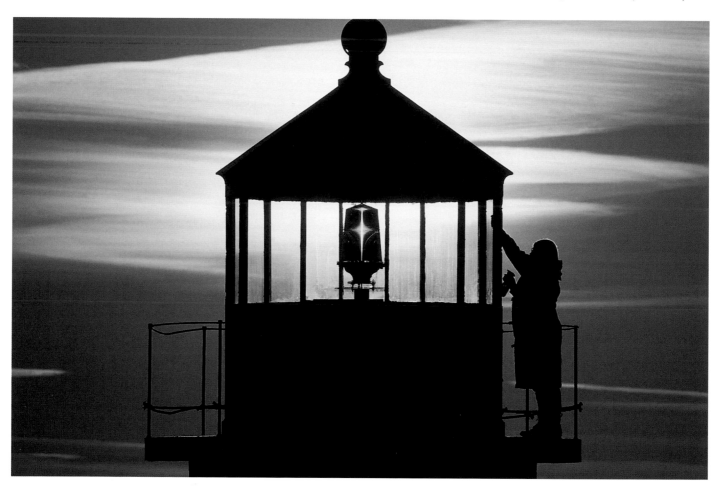

spoke carefully; they surely did not want to say the wrong thing; and they must have been extremely courteous to the inspectors. Such is the way Lee Ann and I reacted and behaved yesterday. After Chief Dutton departed, we felt a sense of pride and gratification because we were confident we had presented our lighthouse with polished reverence, just as other lightkeepers had done for more than two hundred years.

⌐Tom

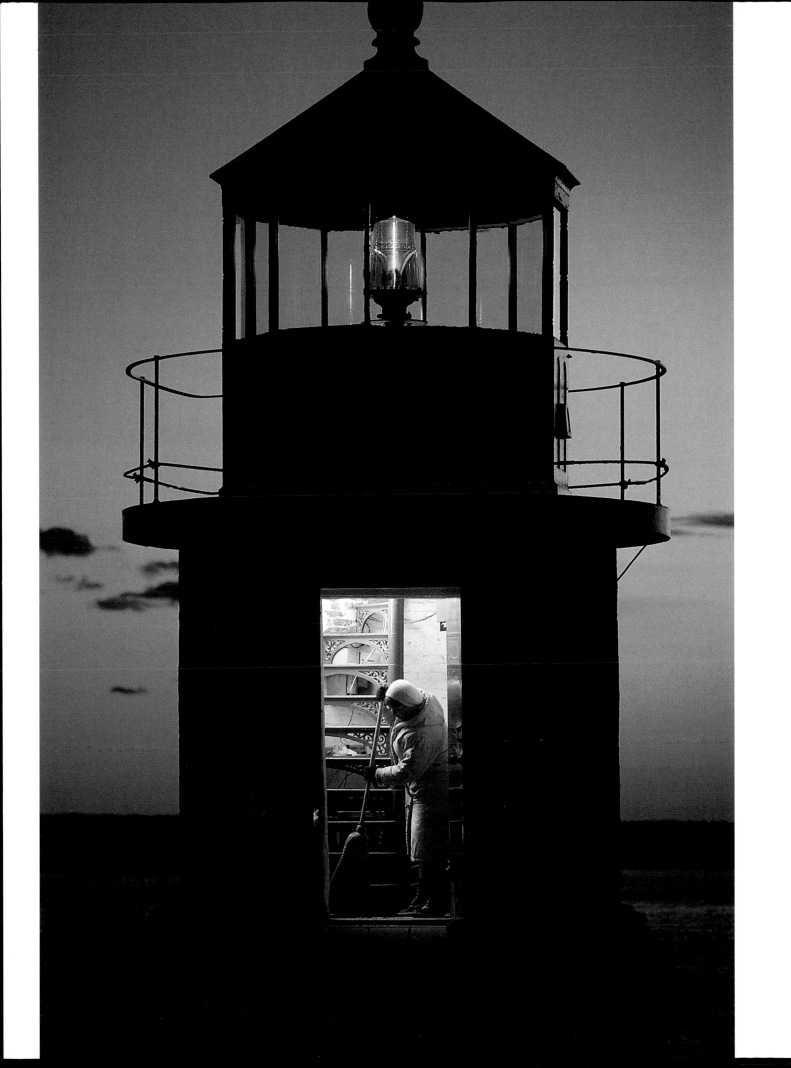

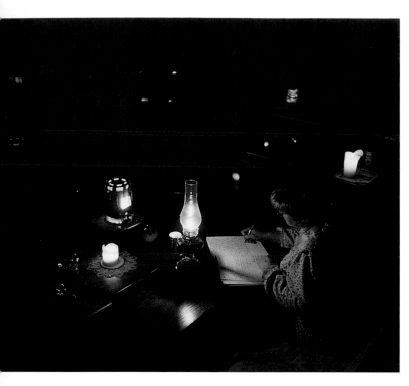

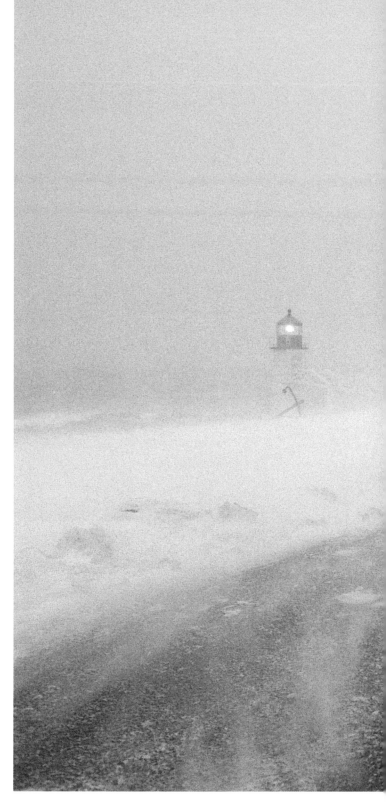

February 4

*I*n the fashion of lightkeepers of yesteryear, I'm compos-
ing this journal passage by the flicker of a kerosene
lantern. Three hours ago, we lost our electrical power
in the midst of a good old-fashioned nor'easter. Outside it is
utterly black; even the light in the tower is disabled. The glow
and scent of wax candles and kerosene lamps permeate each
room with a warm, secure essence. It's a cozy yet eerie night
in the keeper's house. Total darkness is rare at a lighthouse.

We are making good use of a special gift that was
bestowed upon us by Eula Kelley, the daughter of former
lightkeeper Charles Skinner. She gave us a wax candle that
she had made by hand, knowing it would be needed when
tempests blew. She remembered countless powerful storms
when her family was dependent on candles. We felt her
comforting presence with the gleam of the candle.

~*Lee*

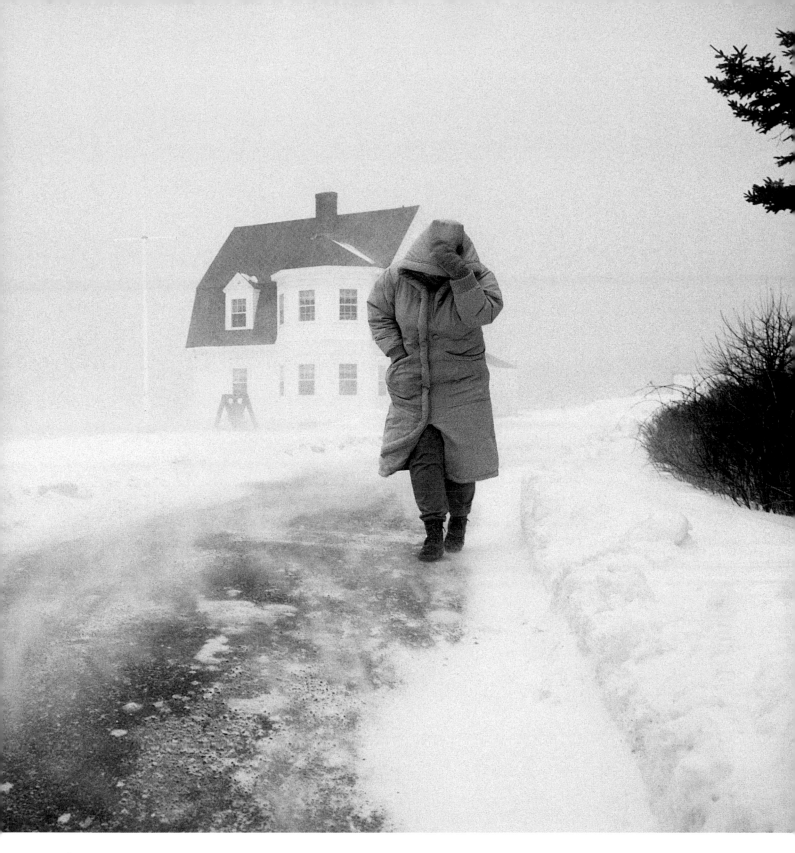

February 5

The blizzard has subsided. The official weather report indicated wind speeds above 70 mph on nearby Monhegan Island. Although we received more than a foot of snow, I didn't have to shovel any of it. The gales blew most of the snow off the exposed portions of the point, including our walkways and vehicles.

~ Tom

February 22

The family of starlings that live in the ventilator ball at the pinnacle of the light tower gained entrance to the lantern room through an opening in the ceiling left uncovered during the refurbishing of the light tower. They left behind a mess.

Lee Ann delicately scraped the accumulated bird feces off the top of the lens with a putty knife. Next, she cleaned the surface with paper towels and glass cleaner. She finished by cleaning and polishing the side of the lens, including the grooves, which act as prisms. Keeping the lens clean and polished is one of the most important responsibilities of any lighthouse keeper.

~ *Tom*

March 15

The Coast Guard sent three men—Charles Dillon, Bob Nyby, and "Mac" McNamara—to replace the aged ventilator ball and its attached lightning rod. Mac was a familiar face to Lee Ann and me. We had befriended him last summer and shared quarters with him for a few days at the Matinicus Rock lighthouse. He was converting the light tower to solar energy and we were photographing the nesting seabirds.

It was obvious that these men are seasoned veterans when it comes to working with lighthouses. It took them less than three hours to remove the old ball and attach the new one. Suspended precariously thirty-eight feet above the rocks, they made the process look effortless. Mac said it was the sixth lighthouse ventilator ball he had replaced.

Utilizing thick rope to secure and lower the ball—still attached to the long, three-pronged lightning rod—Bob cautiously guided it to the footbridge. He rested the ball, and himself, numerous times on the rungs of the ladder that was leaning against the tower.

While Mac secured the new ball with bolts, I told him that on rare occasions we had been able to see the beam from the Matinicus light tower from our parlor window. I also told him that we hadn't been able to detect it at all this past winter, even on clear nights. Mac responded that in October 1994 the light had been converted to solar power, so the strength of the light had diminished. I was dismayed to hear that we probably would never again see the sparkle of Matinicus Rock Light from Marshall Point. Gone is our direct connection to this lighthouse neighbor.

Bob and Mac hauled the old vent ball to the front porch of the keeper's house. It was worn and rusted, with a gaping fracture on one side. The brass prongs atop the lightning rod had turned green from years of exposure to sun, wind, and salt. Fragments of deteriorating metal flaked off the ball's exterior. Remnants of the starling nest, mostly dried grass, fell out of the interior. The starlings will have a new, watertight home. Or will they? Mac tells us he believes they will not be able to enter the narrow vent holes in this new ball.

Coast Guard engineers in Connecticut told the repair crew that the old vent ball was the original one, placed on the light tower when it was built in 1858. The ball served Marshall Point Light splendidly for 137 years. The ball is a significant piece of Marshall Point Light history, and it's now proudly displayed in the Marshall Point Lighthouse Museum.

~ *Tom*

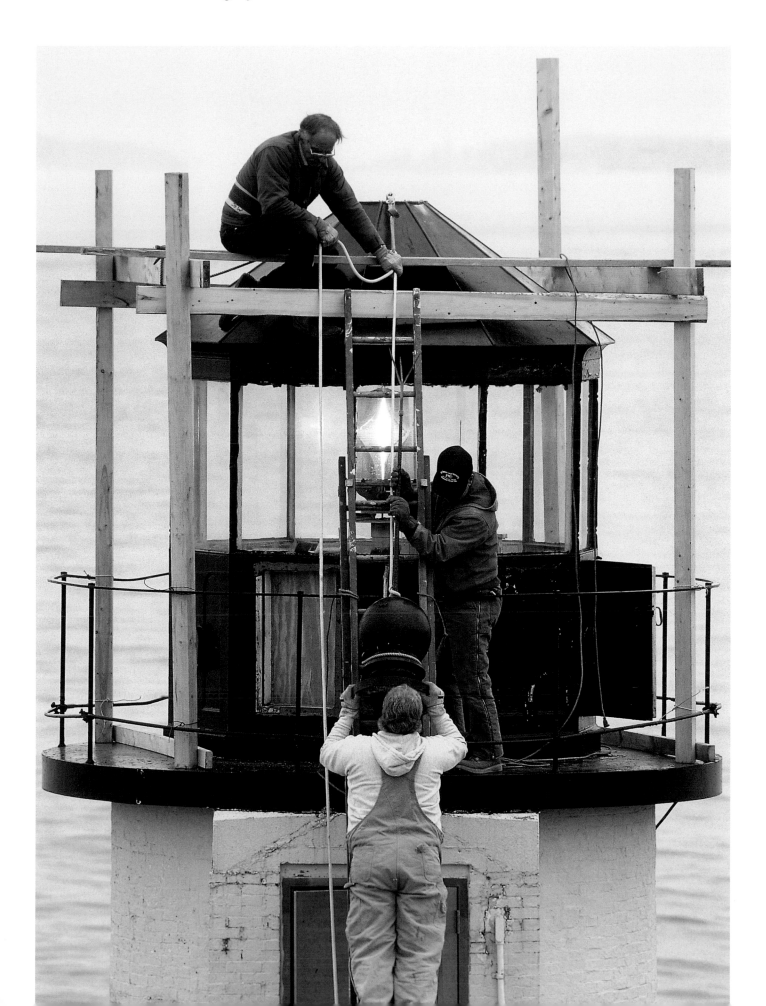

March 28

Our home has been featured in an Academy Award–winning movie. *Forrest Gump* was honored last evening with six Academy Awards—most notably Best Picture. Robert Zemeckis, whose autograph is in the museum's guest book, won the award for Best Director. Tom Hanks won the Oscar for Best Actor for his portrayal of Forrest Gump.

~*Lee*

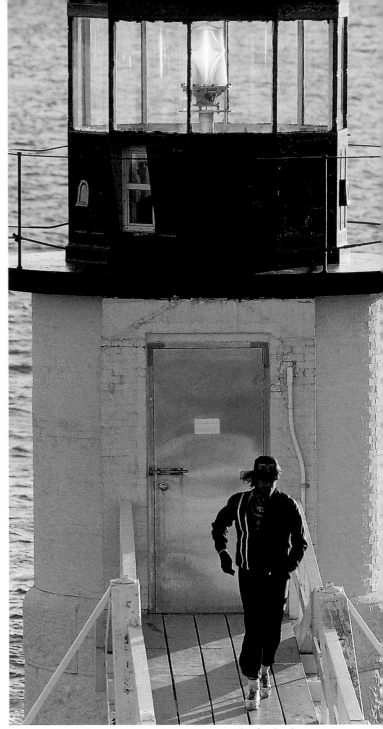

Actor Tom Hanks, as Forrest Gump, runs on the footbridge at Marshall Point.

May 11

As I write this journal entry, I am surrounded by abundant wildlife. Outside the kitchen window, several mallard ducks drift in Stone Cove, along with an uncommon male American widgeon duck. Dozens of common eiders gather, swimming and preening. Two laughing gulls rest after their long migration from the South. Cormorants dive for fish; crows and starlings fly overhead. Mourning doves feed on the ground below the window; two red squirrels search for seeds.

Through living-room windows, I observe more than fifty harbor seals on the Gunning Rocks, including several newborn pups. Herring gulls are dropping sea urchins from the gray sky onto the rocks below.

Last evening, while out for a walk, we encountered Maine's largest land animal. For ten fleeting seconds, we watched a 700-pound moose disappear into the darkness of the night.

~*Tom*

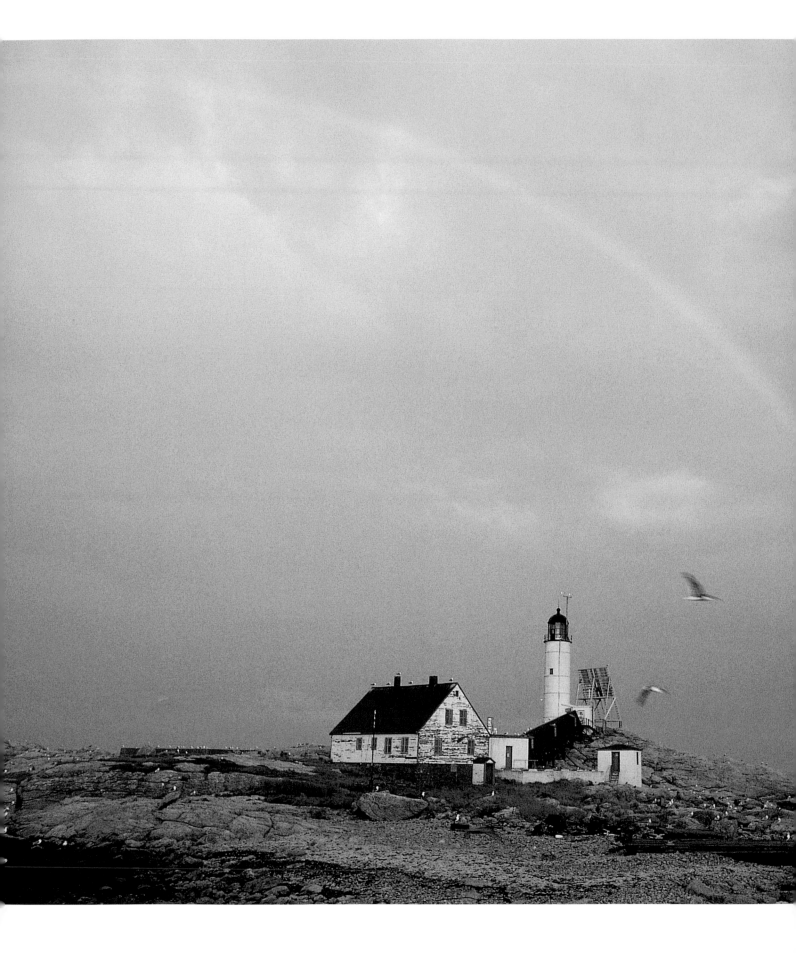

July 23

*T*hroughout this week, Tom will live in the lighthouse on remote White Island in New Hampshire's Isles of Shoals as part of an artist-in-residence program sponsored by the state of New Hampshire. The uninhabited island has no electricity, no phone, and no running water. His lone means of communicating with the outside world will be by hoisting a flannel shirt up a rickety flagpole to alert his contact on Star Island of any emergency. This "flag" is only noticeable from Star Island through powerful binoculars.

⌐Lee

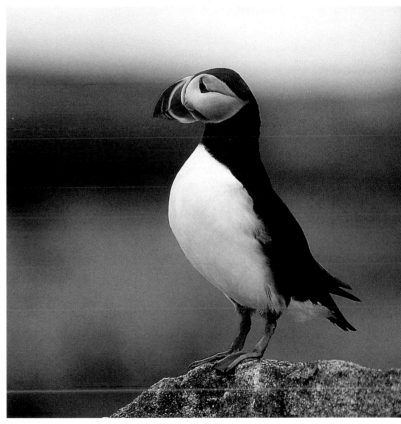

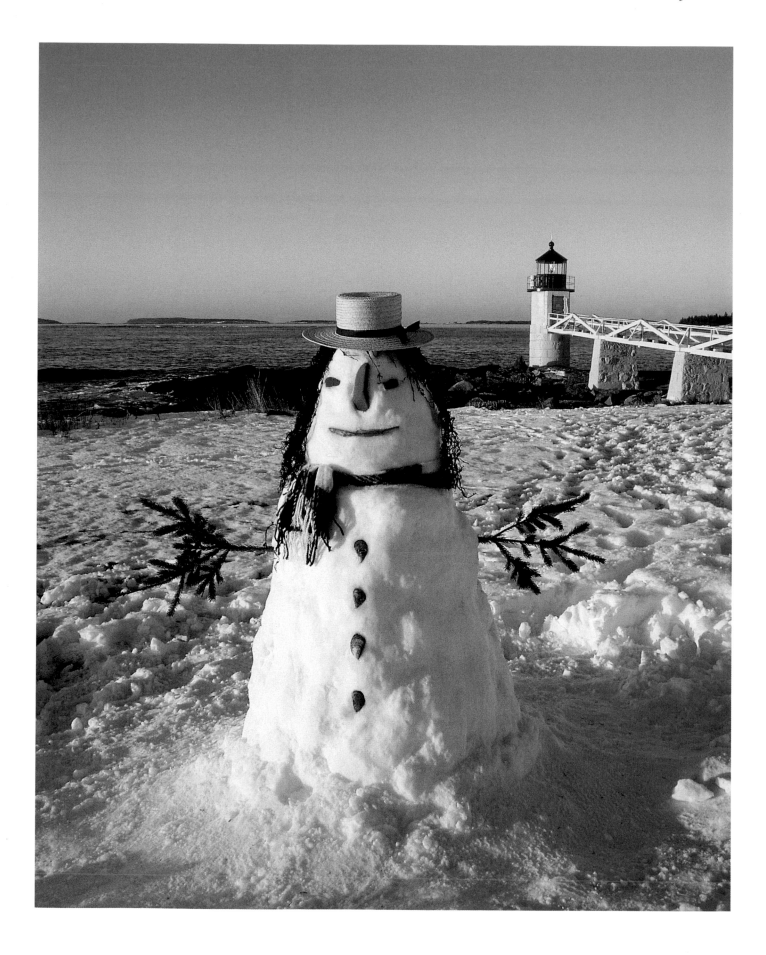

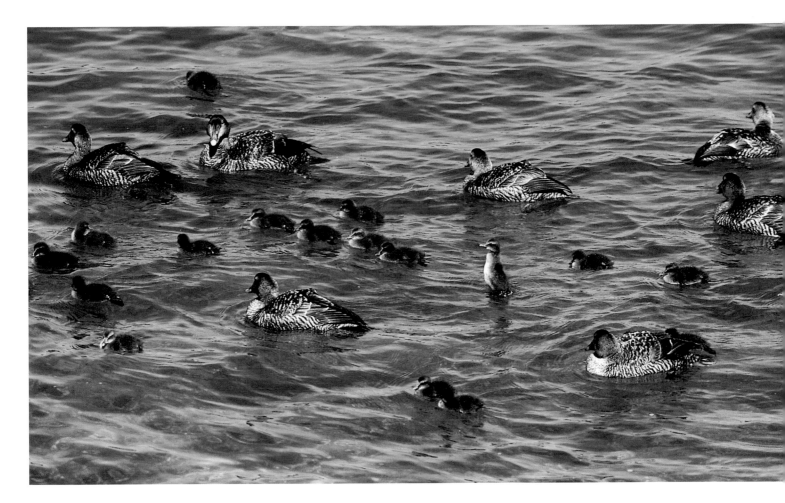

January 16, 1996

We recently created a five-foot snowman, appropriately named "The Keeper." Its eyes and nose were made from smooth, sea-washed stones; its hair was fashioned from seaweed; its mouth was a piece of driftwood; its arms and fingers were made from boughs cut from our Christmas tree; and we used mussel shells for the buttons. We wrapped a wool scarf around the snowman's neck and topped it off with a straw-brimmed hat.

In the following days, we watched several visitors pose for photographs with The Keeper.

⁓ *Tom*

May 22

A sure sign of the approach of summer is the hatching of common eider duck eggs. The first ducklings of the season swim closely behind their mother in Stone Cove. The tiny bobbers of waterproof fluff appear to be only a few days old as they scramble effortlessly up the slick, algae-covered rocks to rest and preen.

When a heavy rain falls, the attentive mother eider shelters her babies underneath her by spreading her wings like an open umbrella. The babies patiently wait for the downpour to subside before venturing out again.

⁓ *Lee*

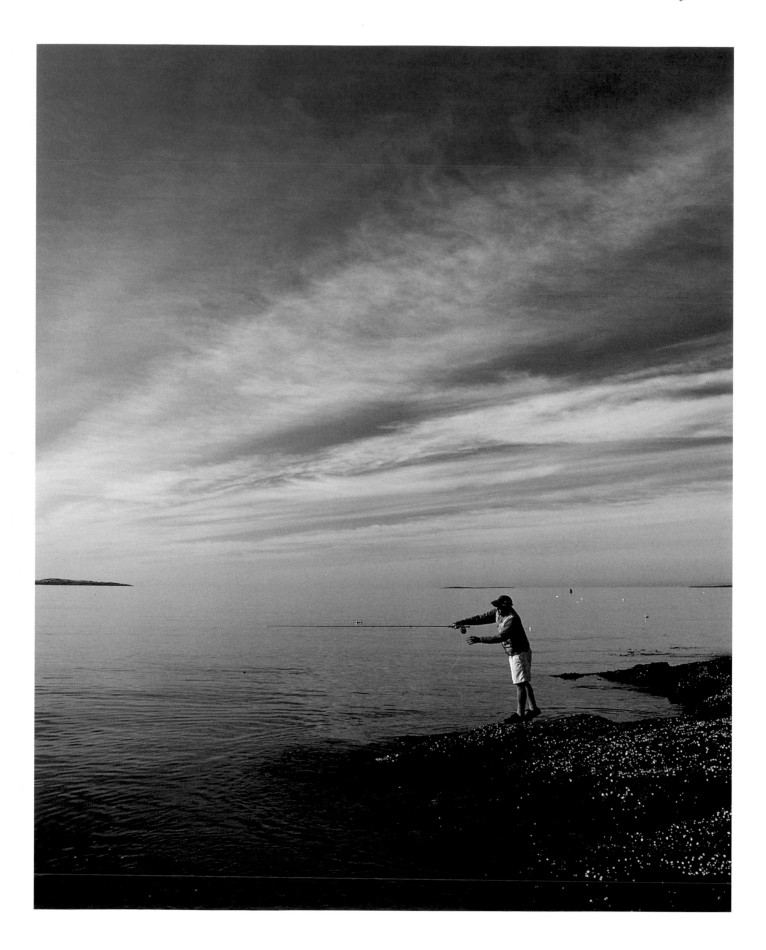

June 19

A t 7 a.m. today, a fly fisherman tested his angling skills on the point. This is the same fisherman we noticed yesterday at both sunrise and sunset. Last evening, amidst throngs of biting mosquitoes, we watched him catch several twelve- to fifteen-inch striped bass.

I photographed the fisherman, John Buck, this morning as he caught one more bass. Thanking him for the wonderful demonstration of his fine fly-fishing skills, I complimented him on his patience.

~ *Tom*

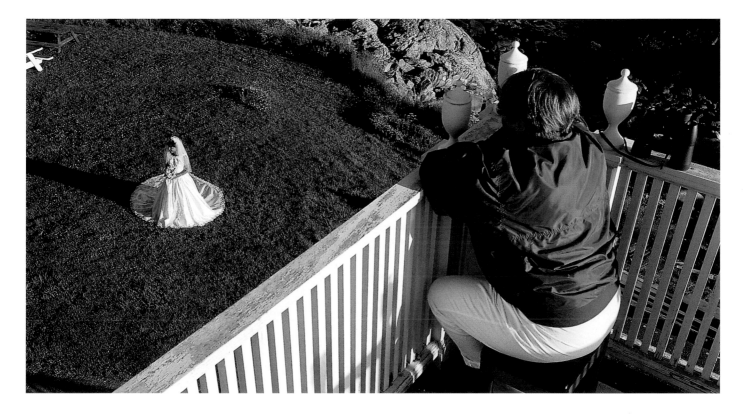

July 7

N umerous weddings have occurred here during the last few weeks. On June 1, Martha Fitz-Simons married Bernie Trombley. On June 2, in the first-ever wedding held inside the Marshall Point Lighthouse Museum, Peter Jones married Alberta Nelson in the cramped quarters of what was once the lightkeepers' living room. The couple from Juneau, Alaska, had intended to marry during an outdoor ceremony, but windswept rain forced the nuptials inside. Another wedding occurred at noon on June 29, when Elizabeth Grimes married Walter David Devault III. The next evening, yet another wedding was celebrated near sunset. On July 6, the harmonious notes of a kilted bagpiper accompanied another wedding party.

How often do these types of events and ceremonies happen without our knowledge? Surely, we cannot witness every occurrence at Marshall Point?

~ *Tom*

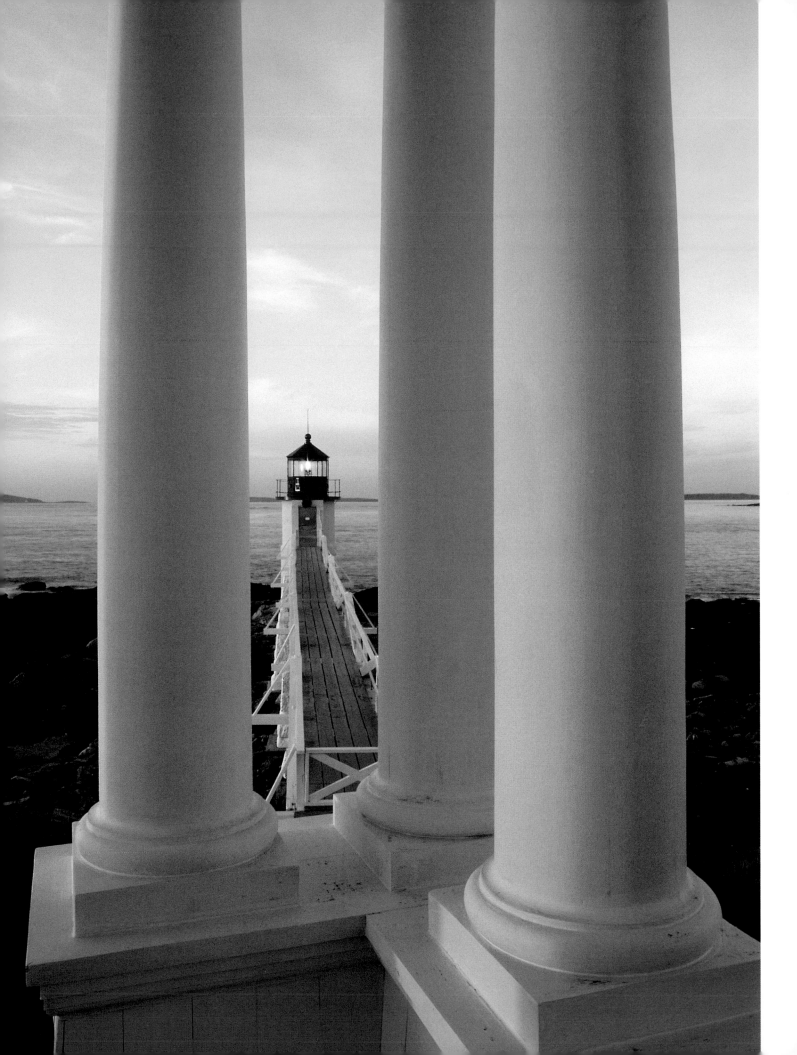

July 21

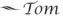e watched with pride and amusement this afternoon as a sightseer attempted to replicate one of my published photographs with her own camera. While the woman finessed her body and camera into position on the front porch of the keeper's house, a young boy held my book, *Compass American Guide to Maine,* opened to page 139 so the woman could see my photograph of the light tower framed by the vertical pillars of the front porch.

⁓ *Tom*

July 29

*L*ast night, under a full moon, Lee and I were serenaded with music from an impromptu concert. Perched near an open parlor window, we had the best seats in the house for listening to three musicians play country, folk, and religious songs. A small audience gathered— some braved the chilly air while others remained in the comfort of their vehicles. Hands and feet tapped to the rhythms, and encouraging applause resonated from the audience after each song. A young man even danced a jig with his dog.

Marshall Point has wonderful acoustics.

⁓ *Tom*

August 10

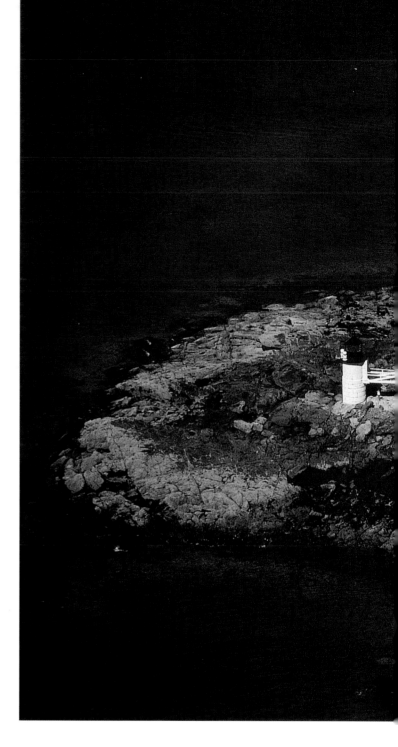

A pleasant day finds us kayaking to the nearby ledges this afternoon. Common eiders, herring and black-backed gulls, double-crested cormorants, and guillemots squawk in protest as we approach Gunning Rocks Ledge. Plovers fly in tight, fluid flocks only inches above the ocean, preparing for their southern migration. Absent are the harbor seals we usually expect to see.

As we continue our journey to The Brothers Ledges, several protective herring gulls urge us away from their nesting territory, flying overhead with their beaks agape and shrieking harshly. Near the water's edge, baby herring gulls entice food from their mother's beak.

Ominous clouds advance from the west. We decide to return to Marshall Point before a squall dampens our trip. While we are paddling home, an inquisitive harbor seal follows close behind us. We turn our kayaks around 180 degrees and paddle backward, to get a head-on view of the seal as it submerges and resurfaces only a hundred feet from us. Seal and humans are fascinated by each other's presence.

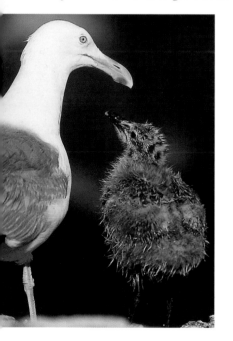

In an ecstatic voice, reminiscent of someone winning a multimillion-dollar lottery, Lee Ann shouts, "Porpoises! Porpoises! Porpoises!" I turn my head landward and see six or eight harbor porpoises swimming only a hundred yards away. Goosebumps appear on my skin and tears nearly flow as I watch the porpoises swim in circles, apparently pursuing a school of fish. I glance toward Lee Ann and see a glorious grin on her face. We float as quietly as possible, not wanting to disturb the creatures. We ignore the harbor seal, still swimming nearby, for the rare opportunity to view the porpoises.

The porpoises turn toward us, chasing the school of fish. When the five-foot-long mammals approach within about seventy-five yards, we hear them exhale as they surface. We watch them in awe for five minutes before reluctantly ending our encounter. The squall line is rapidly approaching.

We hurry home before the weather and seas deteriorate. Paddling toward Marshall Point, we keep looking behind us, expecting to catch a final glimpse of the pod. But we never see them again.

We have dreamed of the day we would encounter our first porpoise from our kayaks, and had always assumed it would be an exhilarating experience. It was!

~ Tom

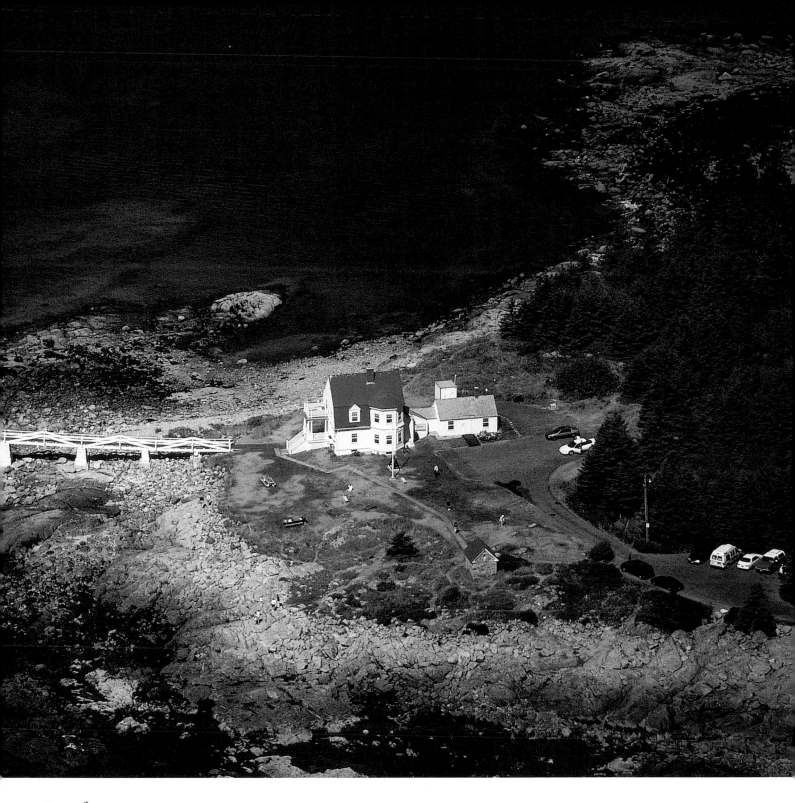

October 11

*T*om and I shared the freedom of soaring over
Marshall Point in an antique open-cockpit biplane
from nearby Owls Head Transportation Museum.
The blustery weather made the flight a bit bumpy, but it was
breathtaking to see our home from such a stirring perspective.

— *Lee*

December 8

*T*he aroma of frankincense permeates the keeper's house, overpowering the salt air. Christmas music plays from our stereo, drowning out the sounds of the gales and storm-swept seas. Puffin, our lighthouse cat, slumbers in a curled ball. Our Christmas tree stands fully trimmed in the parlor, its top branches touching the eight-foot ceiling.

All through last night and this morning, a major nor'easter delivered potent winds, commanding surf, and fierce rain (sadly, not snow). Enduring the turbulent elements, we ventured outside during the peak of the storm to search for our Christmas tree in the forest behind the keeper's house. Winds were blowing at a sustained speed of 50 knots. Waves were ten feet high. Our faces were dripping with salt water from the wind-driven foam and spray. The road leading to the lighthouse was awash, as towering swells swept the shoreline. The receding waters left gravel, stones, and other debris on the road. The breaking waves and buffeting winds were deafening. Flocks of sea ducks struggled in flight. For the first time ever, we risked a visit to the light tower during a storm of such tremendous magnitude. Stumbling on the footbridge, we were totally exposed to the unrelenting brunt of the winds. The cold waters whirlpooled only a few feet below us—too close for comfort. The surf hammered the bridge's

pillars, heaving water across the aging wooden structure. Our clothes were saturated. Menacing waves curled at eye level only a hundred feet away.

Once we were inside the base of the tower, the thick brick walls silenced the wind and sea, but when we entered the lantern room, we again heard the roar of the storm. The windows were streaked with salt, limiting our visibility. Several feet of water surrounded the tower. We were essentially on an island.

Grasping the catwalk railings tightly, we crept around the exterior of the lantern room. Our coats, hoods, and pants flapped violently in the wind, and walking was hazardous on the slick, salt-covered surface. One of the scarier and more exhilarating moments occurred when an eight-foot wave collided with the tower and surrounded its granite base. We were vulnerable, yet we were protected by this masterfully built structure. We silently hoped the raging sea would not destroy the footbridge, our only link to the mainland.

I'm writing this journal entry at 2 p.m., as the storm is abating. The sky is turning blue; the immense waves are dwindling with the outgoing tide. Storm warnings have been reduced to gale warnings. After Mother Nature lashes us with her fury, she anoints us with her peace and tranquility.

~ Tom

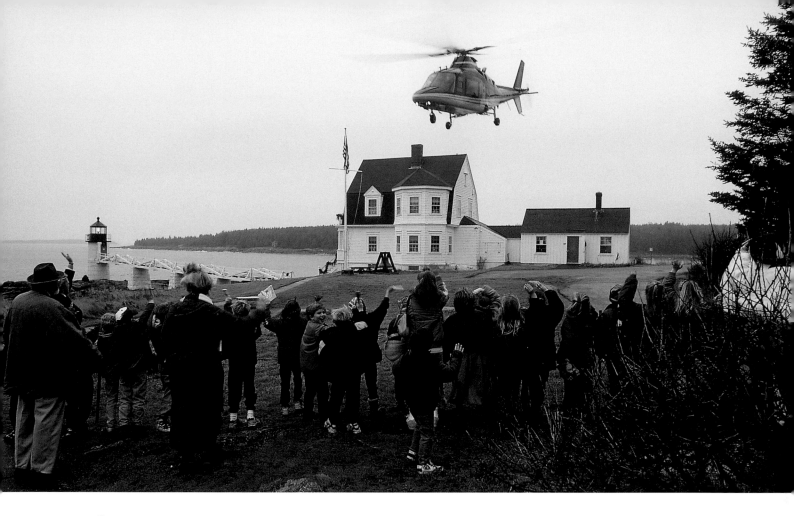

December 17

Last night we leaped up excitedly from our seats as the foghorn sounded. Perchance could snow be falling? Will we indeed have a white Christmas? Much to our dismay, a warm fog, not snow, had activated the horn.

With temperatures above fifty degrees and a steady rain falling, one would think it would be hard to feel any Christmas spirit. But no—the Flying Santa delivered his Christmas magic to us yesterday.

Santa's helper, Lee Ann, invited friends and neighbors to greet him when he arrived by helicopter. Among those joining us were the second-grade class from the St. George Elementary School and our neighbor Paul Dalrymple, a distant relative of the original Flying Santa, Captain Bill Wincapaw.

Prior to the students' visit, they had learned about the seventy-year tradition of the Flying Santa. With great anticipation, everyone remained silent, standing in a light drizzle, waiting for the sound of Santa's "sleigh." Lee Ann's cry, "I hear him coming!" raised goosebumps on everyone. Was Santa's helicopter approaching or had Lee Ann heard the chugging of a distant fishing boat? Thirty seconds elapsed, and then we knew—it was indeed Santa.

The helicopter first appeared over the south end of Hupper Island. The children screamed with joy when the helicopter circled, with Santa waving. They jumped up and down, yelling, "There he is! There he is!"

Santa was greeted with a big hug from Lee Ann and a warm handshake from me. His best welcome came from the children, whom he led into the keeper's house, where he unloaded his sack of presents. Every child received a toothbrush. Each girl also received a picture book, and each boy received a die-cast metal vehicle. Santa and the children sang a fun rendition of "All I Want for Christmas Is My Two Front Teeth," before they all posed for photographs in front of the helicopter.

We all stood near the fuel house to wave good-bye as Santa's visit came to an end. Hats flew off in the rush of air from the departing helicopter.

Santa left behind the customary gift for the lightkeepers. We will wait impatiently until Christmas morning to open the colorfully wrapped box and thus continue a memorable lighthouse tradition.

~ Tom

January 10, 1997

*T*he fury of the sea remains alarmingly unpredictable, even in this modern world of high-tech communications and satellite weather forecasting. Today's forecast called for light rain and snow, but the rain and snow intensified into an unforeseen, spectacular storm that produced damaging surf. It turns out I was about to witness one of the largest-ever storm surges on Marshall Point. This was a storm of which legends are made.

During the storm, the ocean became more powerful by the minute; at first, waves five to ten feet high sent spray halfway up the light tower—about sixteen feet. A huge breaker engulfed the front lawn, flooding a meadow vole's den and sending it scampering to higher ground.

Eventually the waves grew to fifteen feet, hurling heavy boulders onto the lawn. At some places, the ocean surged inland fifty feet beyond the normal high-tide level. Waves slammed against the footbridge pillars, tossing walls of water over the bridge. Several rogue waves soared up the light tower, showering its roof with foamy spray. The road to the lighthouse was flooded and clogged with boulders and debris. Large sections of the road were torn apart.

I spent several hours at the height of the storm taking photographs with my 35mm cameras. To put this storm in another perspective: I shot eleven rolls of film, almost four hundred photographs. As I write in my journal tonight, I'm physically drained.

I now realize how easy it is for mariners to find themselves in the midst of an unpredictable storm that causes shipwrecks, topples light towers, and makes women widows.

⌐ Tom

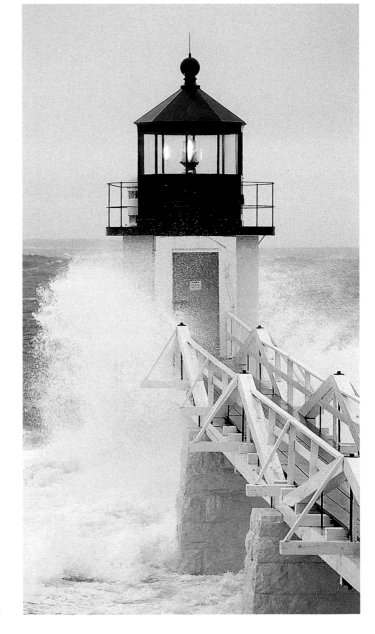

March 9

A steady, light snow fell most of yesterday. A rare absence of wind allowed the powdery flakes to blanket the point like a coating of sugar. At sunset, as we sat near an open parlor window, all of our senses were drawn into the moment. We could hear the sloshing of the ocean at the water's edge. We watched the snow fall and saw the eiders returning to their island homes for the night. We could smell the salt from the ocean and feel the cold air brush our faces while the heat in the house kept our bodies warm.

This morning the point sparkles in the rising sun. Once more, we sit near an open parlor window, this time sipping hot chocolate. We hear the awakening gulls and long-tailed ducks, we feel the radiance from the sun along with the cool tingle from the snow blowing onto our faces, we smell the crisp, fresh air, and we see the crystal-clear sky. It is simple but glorious moments like these that my senses and my memory will always cherish.

~ *Lee*

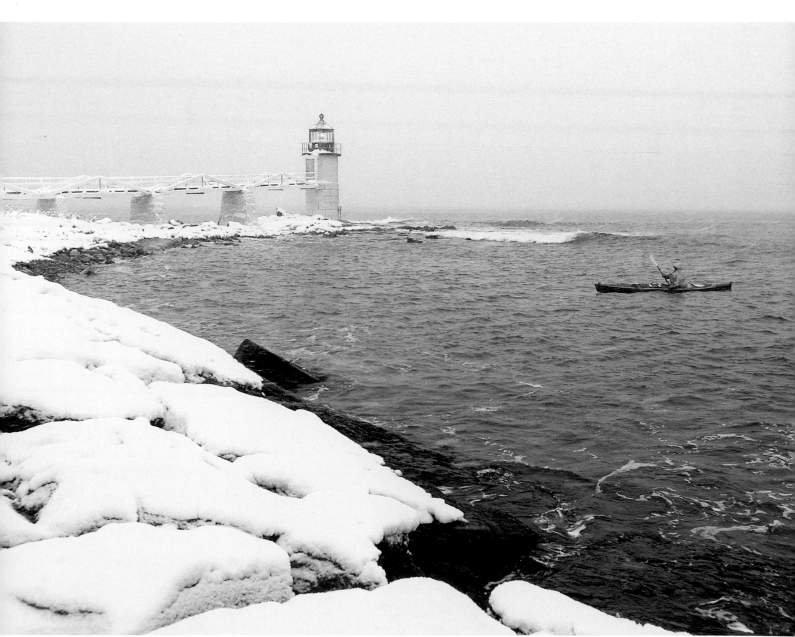

A windless March day provides a chance for a wintry paddle.

March 31

We awakened yesterday, Easter morning, at 5 o'clock, awaiting the arrival of parishioners from several of the churches in the town of St. George. Each year, they gather to celebrate Easter with a sunrise service.

Approximately seventy-five men, women, and children assembled on the damp lawn on the east side of the point. Lee Ann participated in the worship from the warmth of our parlor, where she sat next to an open window, acknowledging many friends and neighbors.

Under the watchful eyes of a gray seal prowling the nearby waters, the service began with a prayer. A guitar and a trombone then accompanied several hymns. A middle-aged woman burst into tears when one of the ministers proclaimed passionately, "He has risen!"

At the conclusion of the forty-five-minute ceremony, one of the ministers approached us and said, "Thanks for being great hosts." We are pleased to have created a welcoming environment for the community.

⁓ Tom

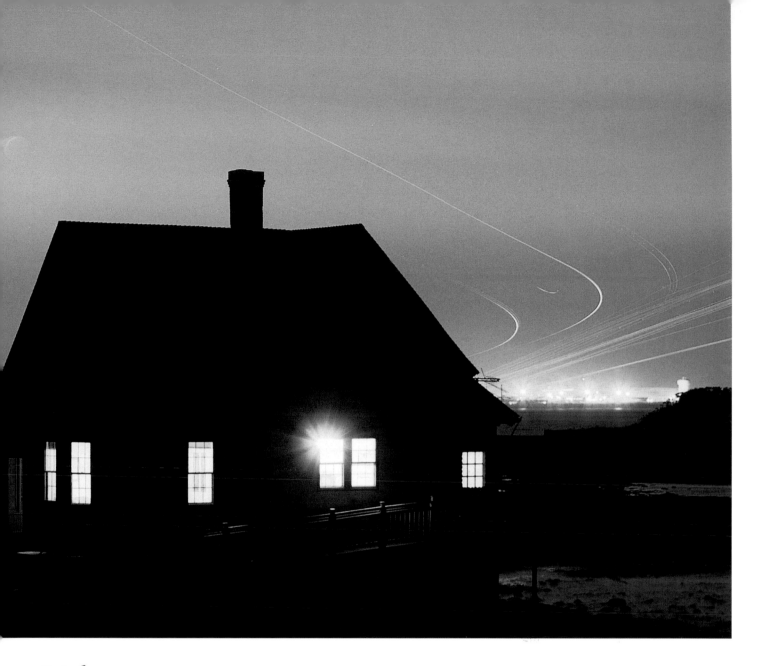

October 15

For several hours, Tom and I have the opportunity to stand in as keepers at Boston Light, on Little Brewster Island in Boston Harbor, while the head keeper tends to duties on the mainland. The history that surrounds this oldest lighthouse in the United States is impressive. For instance, the nation's first fog signal, a cannon from 1719, is still on the island. The tranquility of Boston Light is in stark contrast to downtown Boston, only a few miles away. The skyline of the city looms to the west, and the constant stream of jets going to and from Logan International Airport keeps us mindful of the nearby hustle and bustle.

The purpose of our three-day visit to Boston Light is to do photography for an insurance company's annual report. Tom was commissioned by an advertising firm to make photo-

graphs that fit the report's lighthouse theme. He will also visit and photograph lighthouses in New Hampshire and on Lake Champlain in Vermont.

As I rest my head on the pillow tonight, nodding off in the keeper's house at Boston Light, the sounds outside our bedroom window are identical to those we hear at Marshall Point—the surf, wind, gulls, and peace.

⌐Lee

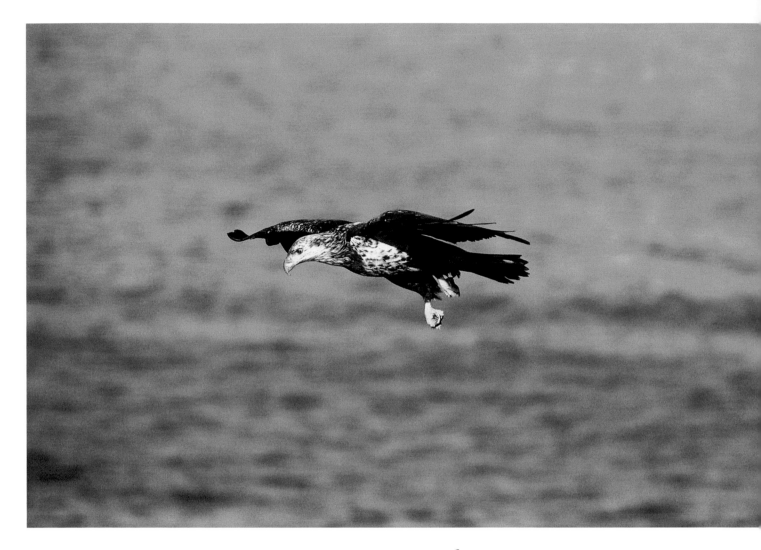

November 26

A quick glance out a kitchen window reveals an immature bald eagle soaring only about two hundred feet away. As I sit by the salt-flecked glass, gazing intently at the impressive bird, we are eye to eye.

It flies toward me, closer and closer, until we are only fifty feet apart. As we make direct eye contact, a stiff wind allows the bird to hover in place.

~ *Tom*

January 24, 1998

There is no better place during a storm than Marshall Point. Last night we ventured onto the footbridge in a raging 45-knot wind created by a brewing nor'easter. The wind was forcing the falling snow to descend almost horizontally. The foghorn was howling and the surf thundering. We had to shout to hear each other. Gazing up into the shaft of light emanating from the lantern room, we became dizzy as the snow sped across the narrow rays. With each streaking snowflake resembling a star, we felt as if we were rocketing into space as a million stars whipped past us. We were on a space odyssey without leaving the point.

⁓ Lee

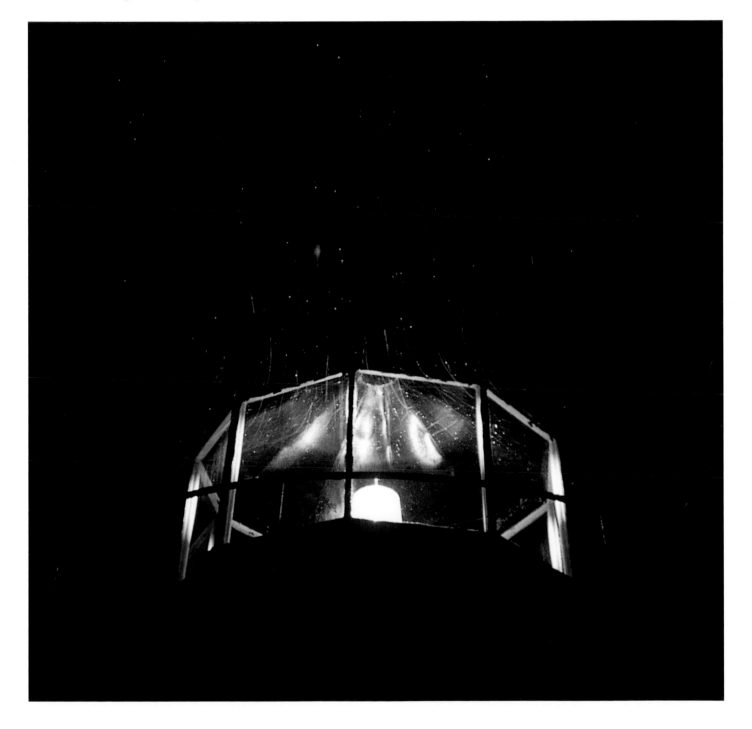

March 11

*I*t started with Article 1, then Article 2, then 3, and so on. Approximately an hour and forty-five minutes later, Article 25 was finally up for debate. I had sat through discussion and voting on each of the articles on the warrant at last night's annual St. George Town Meeting, all the while growing increasingly anxious.

Jim Skoglund, moderator of the meeting, introduced Article 25: "To see if the Town will vote to authorize the acceptance of the Marshall Point Lighthouse property in Port Clyde as granted by the Lighthouse Selection Committee." My heart raced, my chin quivered, and I gazed at Tom with pride.

Jim said, "All those in favor of Article 25, please raise your hand." Then: "All those opposed, please raise your hand." Only one person was opposed. Jim said, "Article 25 is approved," and with the pounding of his gavel, it became official. Jim commented on how lucky the town was to acquire this magnificent property. The audience applauded and Jim asked the lighthouse board members to stand and be recognized. As I stood with the other members, my eyes overflowed with tears.

⁓Lee

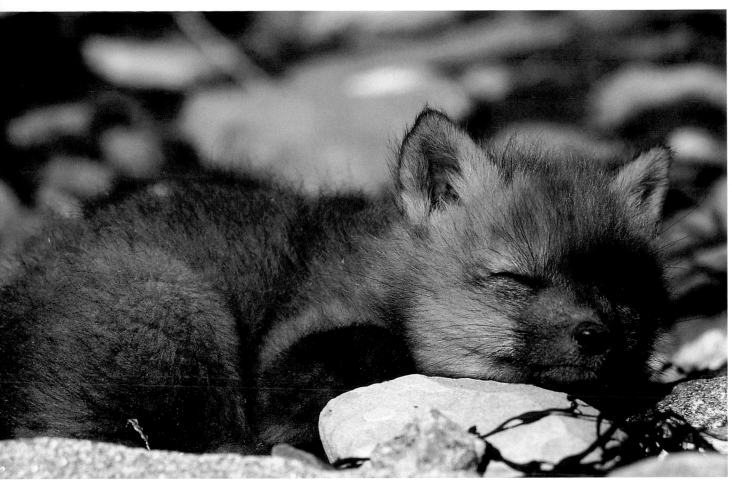

A red fox kit sleeps near its den along the shoreline of nearby Howard Head.

March 26

*I*t is customary for Lee Ann, upon awakening, to peek through the window blinds to see what awaits her each morning. Surprises are not uncommon, like the one she received yesterday. At 5 a.m. she called, "Tom, come quickly!" I leaped out of bed, rubbing my weary eyes, and just reached the window in time to see an adult red fox scamper under the footbridge, hunting for its breakfast.

The fox scurried along the slick rocks to Stone Cove, alarming the gulls and ducks. After the birds and the fox stared at each other briefly, the hungry fox climbed onto dry land and gorged itself on sunflower seeds that had fallen from our birdfeeders, ambled down a narrow path, and vanished into the forest.

This was our fourth sighting of the fox within three weeks. Perhaps it has a nearby den with pups.

⁓ Tom

April 5

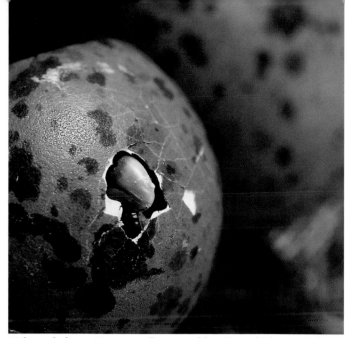

A herring gull feeds upon a live crab the size of my hand. The gull had managed to avoid the crab's powerful claws and easily tore into its thick shell with hammerlike strikes from its sturdy beak.

More herring gulls jockey for position to steal fish scraps from a gray seal as it surfaces with a fish wiggling between its fore flippers. There's no shortage of food for the gulls—these opportunists flourish because they are resourceful and intelligent.

— Tom

Right and above: Herring gull nest and hatching chick on nearby Hart Island.

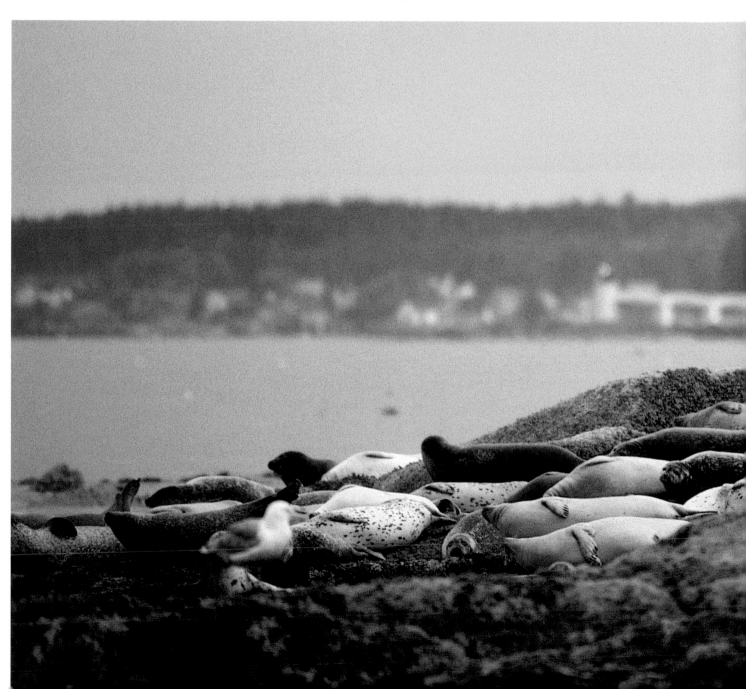

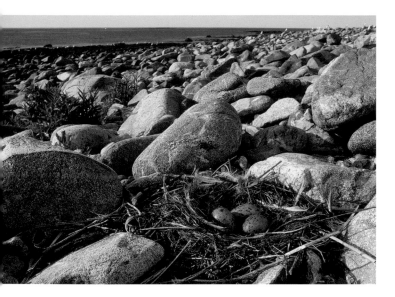

April 13

Marshall Point's variation on the grand return of the swallows to Capistrano, signifying the arrival of spring, is the annual return of harbor seals to their birthing rookery on Gunning Rocks Ledge. Yesterday, the first seals of the season were spotted resting on the ledge at sunset. Spring has officially arrived on Marshall Point.

~*Tom*

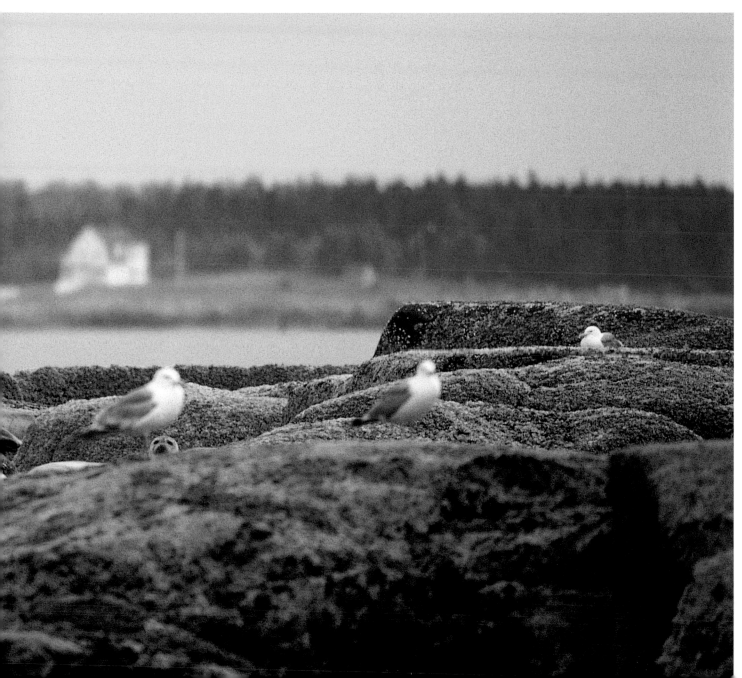

Unlike the fabled Muscongus monster, this serpentine wave was real, but what could have caused it?

May 25

During the last few weeks, we have met several people who have claimed to have seen a large animal in the waters southeast of Marshall Point. One person mentioned encountering it while sailing. Each one insisted that it was no whale, but rather a creature resembling an extraordinary large reptile. When I joked that it must have been the Loch Ness monster, no one laughed. These folks were serious.

This morning, a group stood in front of the keeper's house, excited about something. I opened a window and asked them what were they watching. One replied, "We just saw the creature!" I politely explained that they probably were seeing the reef that is sometimes exposed at low tide near Hart Island, but they were convinced they had seen a creature, not a reef.

Now curious, I ventured outside to see for myself. I approached the group and said, "So, you have seen the Muscongus monster?" After they pointed to the location of their sighting, I was even more convinced they were seeing the reef appearing and disappearing with the action of the swells.

Later in the day a visitor from the Midwest approached me and asked if I had ever seen the Muscongus monster. I shook my head and said no. I did suggest that he look toward the right side of Hart Island, and I told him that people had claimed to have seen the creature there this morning. When I asked him where he had heard about the monster, he said, "From our innkeeper in the village."

Is that how legends are born?

— Tom

July 11

A flash of light in the eastern sky captured my attention last evening as I gazed out the parlor window. It was the beacon from Matinicus Rock Light, about twenty-three miles away. Ethereal clouds above Matinicus Rock were glowing pink against the night sky, and their color deepened as the full moon rose directly over the island.

— Lee

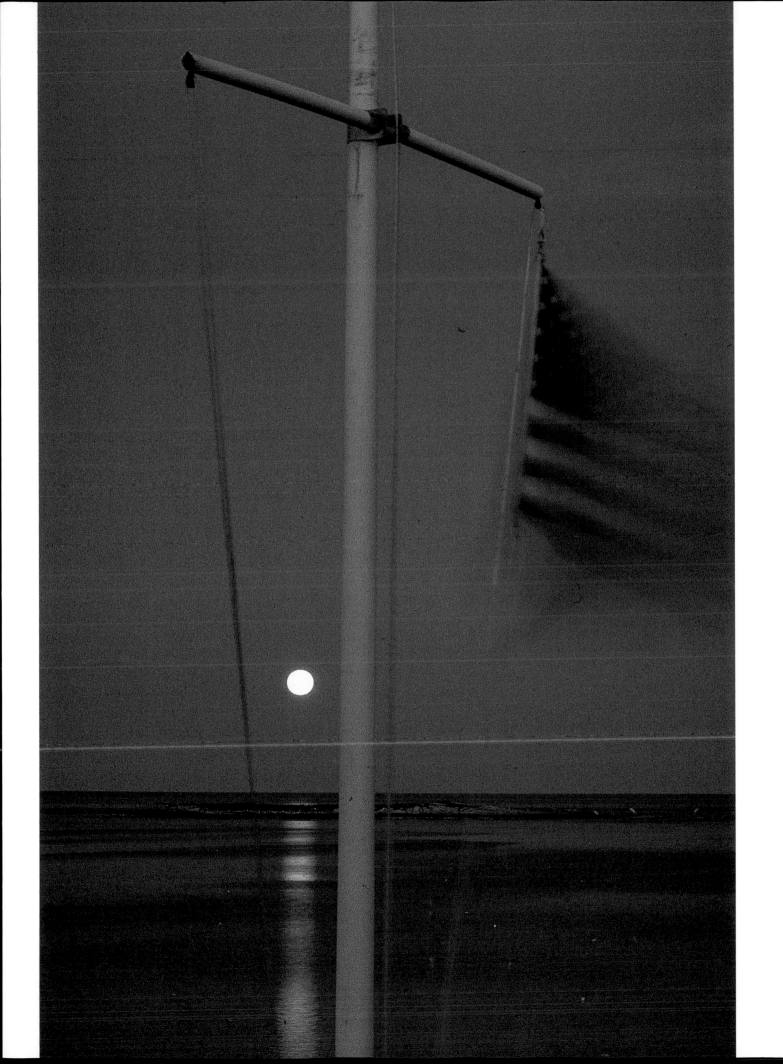

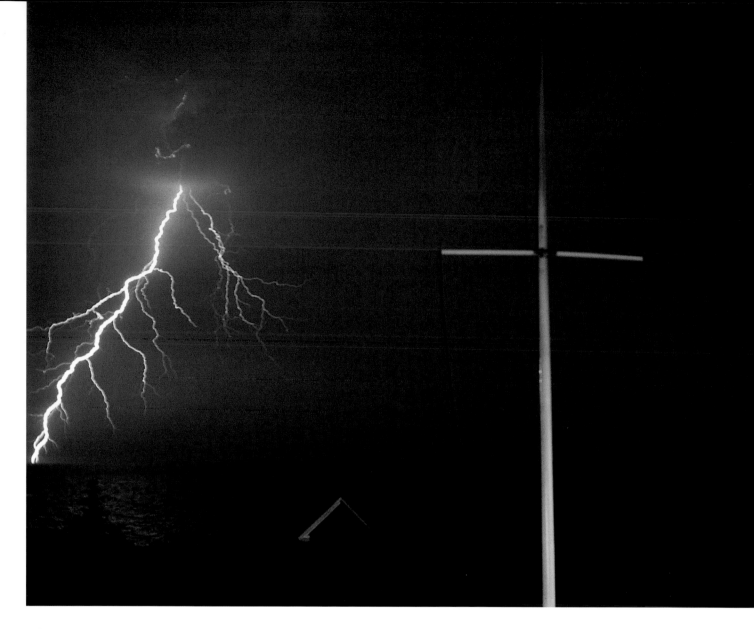

August 26

Last night we sat in the parlor, feeling unsettled as an advancing thunderstorm grew progressively brighter and more deafening. Then it came—the resounding, nerve-wracking explosion of a lightning strike. We jumped several inches off our seats. Puffin, one of our cats, hugged the floor and stared at us with panicked eyes, panting. Lee Ann and I had almost the same reactions. It would be an hour before our heartbeats returned to normal.

We did not know immediately where the lightning had hit, but given the history of this light station—the first keeper's house had been destroyed by lightning in the late 1800s—our foremost concern was for the house. I sped to the attic to see if the lightning had struck the roof. I could not see, hear, or smell any indication that it had. We also checked the roof of the summer kitchen and the nearby trees, but there were no signs of lightning damage. Then, from the safety of the keeper's house, we looked up at the light tower and saw the light flicker and fail. The tower had been struck.

After waiting half an hour for the storm to blow eastward, we went out to the light tower. Upon entering, we instantly were overwhelmed with the distinctive smell of an electrical fire. We opened the electrical panels but failed to locate the source of the problem. From the top of the tower, we stared at the display of lightning beyond Matinicus Rock, to the east, grateful that our house had been left untouched.

At our request, the Coast Guard sent a team this morning to fix the problem. Dario DelCastillo and Ivan Villanueva quickly located the cause of last night's odor—a burnt relay switch—and repaired the damage.

— *Tom*

January 1, 1999

After a temporary power loss, we regained our electricity in the house, but the light in the lantern room remained off. That means I have to make the short but intensely cold journey to the light tower to switch on the light manually.

The blue glow of a full moon illuminates my way to the tower. The frozen timbers on the footbridge moan with each step. The temperature is five degrees Fahrenheit, and the northwest gales are striking the point with unimaginable force, producing an estimated wind chill of minus forty degrees Fahrenheit. In the less than two minutes it takes me to reach the door to the tower, my exposed face is stinging with pain.

Wearing cumbersome gloves, I struggle with the frozen brass padlock, which I cannot manage to open. I retreat to the keeper's house, my lungs and face still in agony from the extreme cold. Lee Ann suggests trying hot water to thaw the lock.

Returning to the light tower, I pour the water onto the lock, immediately freeing its mechanisms, but then I encounter another obstacle, testing my perseverance: The door is stuck to the footbridge by a sheet of ice. A few forceful kicks dislodge the icy grip. Once inside the tower, I simply press a reset button on the electrical panel to activate the light.

~ *Tom*

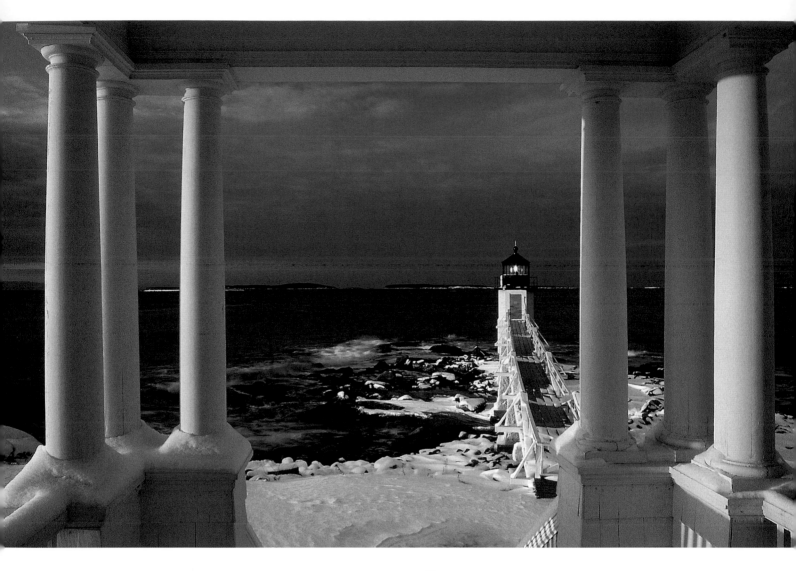

January 14

I have been outside in the brutal yet stimulating cold for more than two hours, enduring a temperature of minus nine degrees Fahrenheit—one of the lowest temperatures we have recorded on Marshall Point.

To my amazement, I see two snow buntings hopping on the crusty snow, searching for food. The wind-chill temperature is minus twenty-five degrees. Despite the dangerous chill, I find these weather conditions oddly appealing. The uncontrollable forces of the environment and the precarious elements of nature are remarkably humbling.

I am warm now, sheltered in the keeper's house, no longer needing the chemical handwarmers to keep my fingertips from freezing to my camera and tripod.

~ *Tom*

January 25

An unusual silence fills the keeper's house. My stomach muscles are tense and my insides churn unnervingly. When I stand, my legs feel rubbery.

Our nearest neighbor and friend, the Atlantic Ocean, turned violent tonight. Our peaceful world is shattered. Four of our neighbors, departing nearby Hupper Island after working all day on the renovation of a cottage, are missing in Herring Gut after their boat capsized. I am frightened and worried. The power of the sea makes me feel weak.

Lee Ann and I watched helplessly from the second-floor porch. In the darkness, we could see the flashing blue lights of Coast Guard and Marine Patrol boats. Several fishing boats zigzagged across the Gut in a loose search pattern, their floodlights scanning the shoreline of Hupper Island. A U.S. Navy search helicopter flew overhead, its powerful searchlights illuminating the gloom.

During each sweep of its search pattern, the helicopter flew right over the lighthouse, focusing its searchlight on us and temporarily blinding us. As the light traced the ragged shoreline, we watched in silence, praying for a miracle and hoping to catch a glimpse of the helpless men.

An hour after the search began, the helicopter hovered for an extended period near the northwest side of Hupper Island. Surely no one could survive the waters of the North Atlantic in January, so we were not hopeful.

The helicopter retrieved two bodies from the frigid grasp of the ocean. Miraculously, the other two men managed to survive by swimming back to Hupper Island after the boat capsized. At least some of our prayers have been answered. A hearse is parked near the Port Clyde General Store, waiting to transport the two bodies.

Writing this journal entry, I fight to avoid what happened to Lee Ann a few moments ago—a torrent of tears.

~ *Tom*

A time exposure shows the search pattern of lights from a rescue helicopter.

February 28

I hunker down inside the lantern room of the 203-year-old Montauk Point Light on Long Island, New York. Around the 110-foot tower, the winds moan at 40 mph, and raindrops pellet the glass windows circling the rotating lens, nearly drowning out the sound of the bellowing foghorn. When I ascended all 137 steps alone in the roaring wind, I had felt uneasy. The agitated ocean stirs grayish-white with foam below me. The light continued to glow brilliantly.

Our cherished friend Marge Winski, keeper of Montauk Light, has been a wonderful hostess. I am amazed at how alike we are, possessing the same qualities as any dedicated lightkeeper. She is an especially generous person, and we feel fortunate to be her friends. Imagine her pride when she showed us the original decree, signed by Thomas Jefferson, that authorized construction of the light at Montauk Point.

In the keeper's house, we spend the night in the room now known as the Admiral's Quarters. It received its name after the commandant of the U.S. Coast Guard, Admiral Robert E. Kramek, stayed here with his wife during Montauk Light's bicentennial celebrations in 1996.

—*Lee*

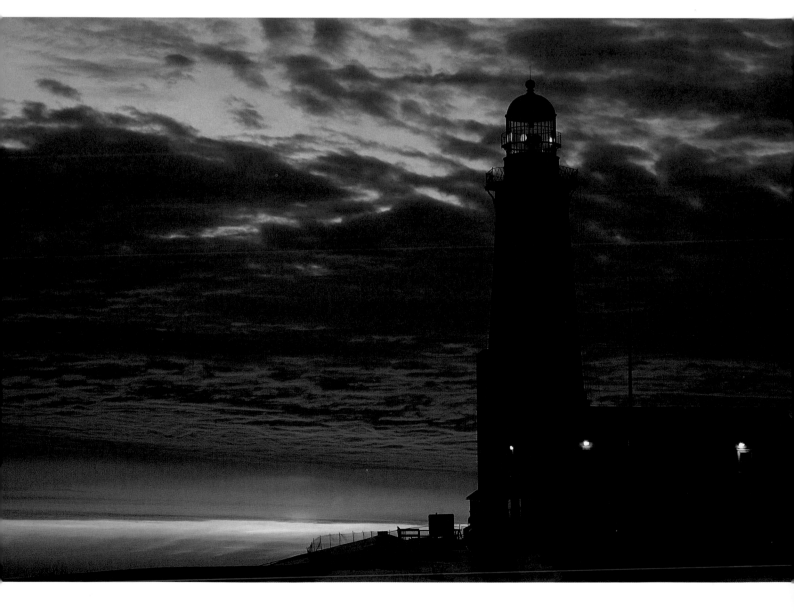

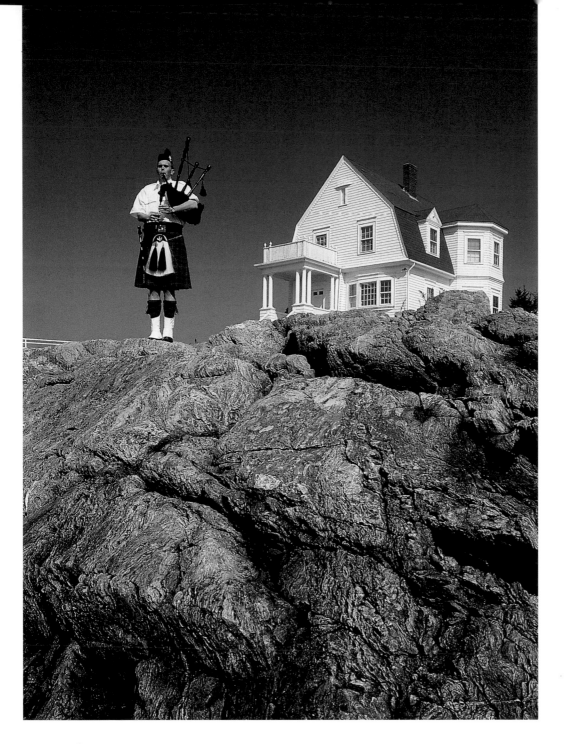

March 24

Working in my office, I am pleasantly distracted by the haunting melody of a bagpipe wafting through the open window. Our friend Ian Erickson stands in front of the keeper's house, dressed in a traditional kilt and playing his captivating Scottish instrument.

His music sometimes reminds me of traditional sea chanteys. Ian comes here from his house in Thomaston to practice, so he can "give his neighbors a break."

～ *Tom*

April 15

I feel heavyhearted as I stare at my right hand. It is covered in dust: fine, ashy, grayish-black dust, the cremated remains of a man I never met.

Today's emotional tribute reminds me of Marshall Point's effect on the hearts and souls of people like James Andrew "Drew" Griffith, a Maine State Trooper who was fatally injured in an automobile accident in Thomaston, Maine, while on duty. That tragic accident occurred three years ago today.

Soon after Drew's untimely death, his father, Ralph Griffith of Asheville, North Carolina, placed a granite bench at Marshall Point in memory of his son. It was near this bench, located between the fuel house and the keeper's house, that the family gathered this afternoon to remember a father, a son, a husband.

I first noticed Drew's widow, Kate Braestrup, sitting on the bench, while her four children played in a tide pool near the light tower. A grand colorful urn sat next to her while she wrote in what appeared to be a journal. She paused occasionally to read what she had written. Her eyes seemed to reflect upon happier times.

Soon her children and Drew's parents joined her. The urn was opened and each child, as well as Kate, reached in to grasp a handful of ashes. With care, they solemnly sprinkled some of the ashes on the ground near the bench. From inside the keeper's house, I watched as they rubbed more ashes on the seat of the bench.

When I went outside to photograph this poignant moment, I was welcomed with moist eyes and friendly smiles. They were flattered and touched that I would be interested in photographing their tribute.

More tears were shed while the family huddled together near the bench. Ralph Griffith told me that Marshall Point had been very special to his son. Ralph fondly remembered the father-and-son conversations they shared here.

The children spread more ashes on a nearby flower bed, where daffodils would soon blossom. As Ralph continued to disperse the remaining ashes underneath the memorial bench, I heard one of the sons say, "Good-bye, Daddy."

A member of the family picked up the urn and the group walked cautiously to the low-tide mark near the light tower. Drew's father remained behind—perhaps because the rocky shoreline was too slick or maybe he just needed to be alone. Kate slowly stepped to the water's edge and cast the urn's cover into the ocean. Seconds later, she tossed the urn into the water as well. We all stood in silence, watching it float in the current.

It was time for me to leave the family alone with their peace. Drew's mother, Gail, expressed gratitude for my visit and for sharing Marshall Point. I promised I would send them copies of the photographs I created. Kate approached and shook my hand. I returned to the keeper's house with Drew's ashes covering my hand, feeling spiritually connected to him because of our mutual interest and passion for Marshall Point.

~ *Tom*

June 3

After nearly ten years, we still find ourselves amazed and awed by the beauty of the point. The longer we live here, the more we fall in love with it. It will be difficult to leave, if that time ever comes. Our passion for the point has not waned.

I sit in the parlor, glancing out a window and recollecting about the weekend just past. The highlight was a moonrise kayak paddle. The winds, tides, and currents were remarkably calm, allowing us to float lazily only a few hundred feet offshore—the perfect conditions for such a cruise.

We were the only ones on the water at sunset. No commercial or recreational boats marred the mellow sounds of nature's symphony. The lyrical tunes of harbor seal pups barking from the nearby ledges were accompanied by the giggling of laughing gulls and the ever-present songs of the herring gulls. Thunder pounded in the distant north. Several adult harbor seals circled our gently floating kayaks. As they surfaced only fifty feet from us, we heard them exhale, and we watched one swallow a fish. Flying overhead was a stately adult bald eagle. A lone osprey soared near Hupper Island, hunting for fish.

The full moon rose gradually over Gunning Rocks Ledge, its pink glow muted by thin clouds near the horizon. The profiles of whiskered seals were silhouetted by the moon's reflection on the water's surface.

With darkness advancing, we idly paddled homeward, entering Herring Gut as the moon emerged above the lighthouse. During our two-hour paddle, we were the only two people on the planet. This peaceful world was ours.

— *Tom*

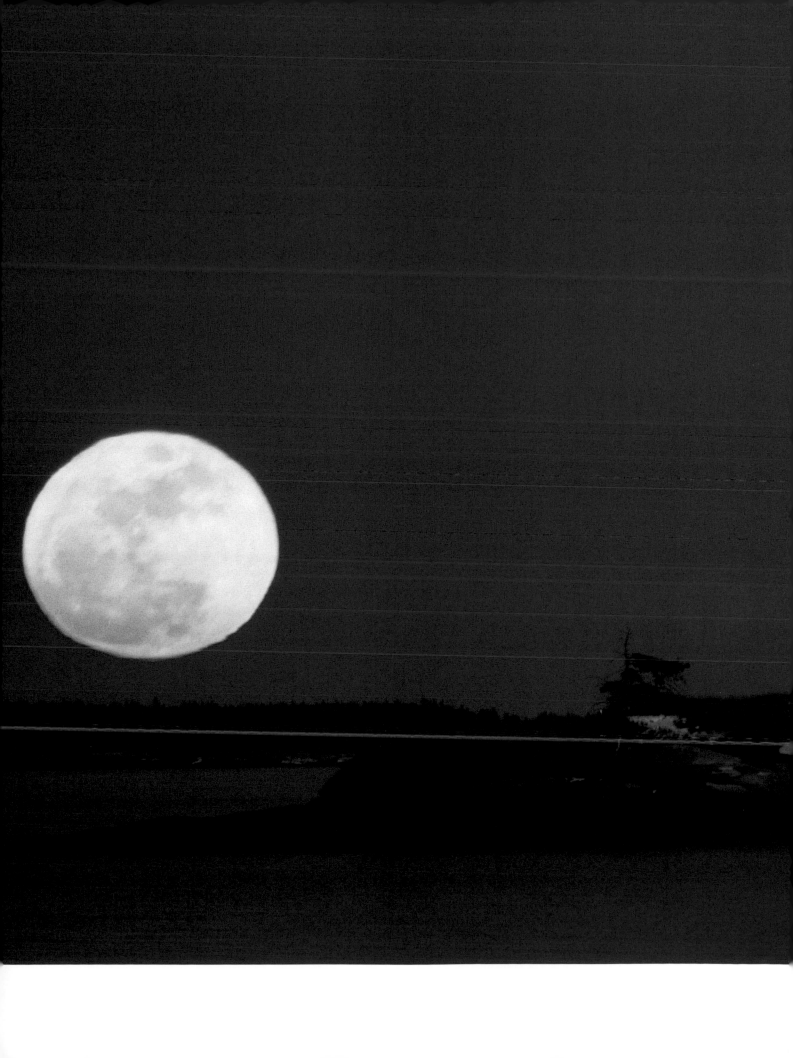

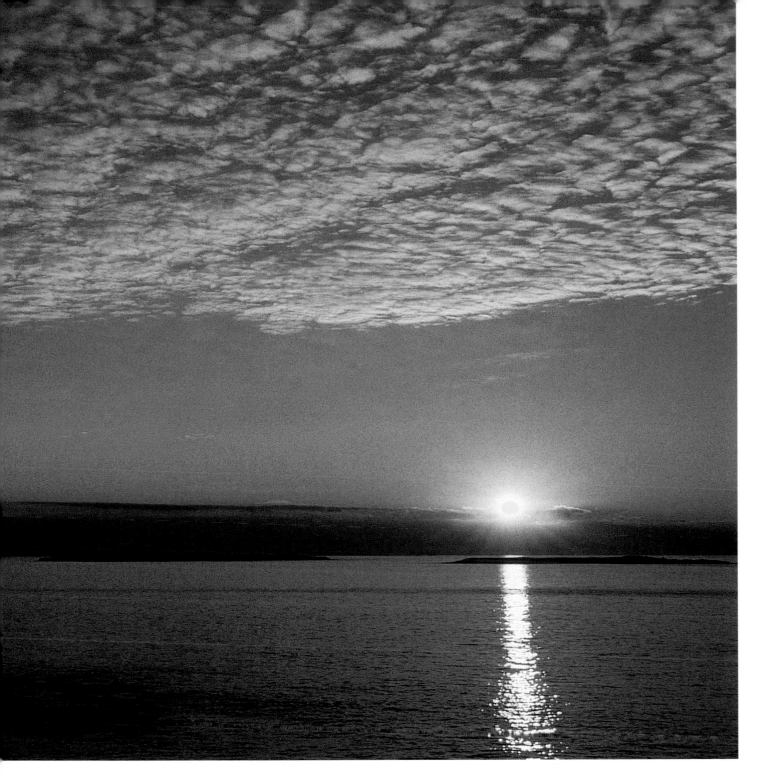

January 1, 2000

Happy new year! Happy new century! Happy new millennium! We began the new year by following our tradition of sitting atop the light tower to watch the first sunrise of the year. We normally have the point to ourselves on this holiday morning, but this is no ordinary New Year's Day. Throngs of visitors arrived on the point to witness the beginning of the new millennium. Nearly three dozen people—many carrying containers of warm beverages—gathered on the rocks. We had the grandest view of all, seated thirty-five feet above the sea.

When the sun penetrated the cloudy horizon, boisterous applause emanated from the crowd. A harbor seal poked its head out of the water to see what the commotion was all about. The new millennium indeed had begun.

— Lee

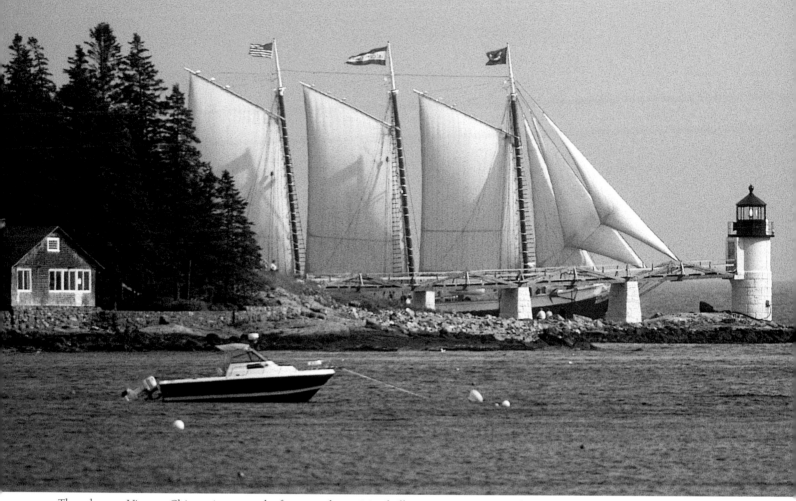

The schooner Victory Chimes *is among the first to sail past Marshall Point en route to Windjammer Days in Boothbay Harbor.*

June 21

What a wonderful life we have at Marshall Point Light. We are spoiled to the core of our souls. Even after living on the point for more than a decade, we still can't wait to experience each new day. Our excitement and enthusiasm for living on this spectacular piece of rock are as strong as on the first day we arrived here.

Yesterday morning, we took a peaceful kayak journey at the first hint of dawn. This was the first time we have gone paddling before going to work for the day. What prompted our excursion was our hunger for a closer look at schooners anchored in the inner harbor. Typically, we only view these majestic vessels as they sail past the point.

A layer of salted haze filled the warm air. The flowering lupines, which Lee Ann planted several years ago, sweetened our senses. By 5:30 a.m. we were floating above a school of tiny, silvery fish in Stone Cove. Eider duck families swam on the tranquil surface and cormorants flew overhead.

The morning sunlight sparkled off the moist wooden hulls and towering masts of the *Nathaniel Bowditch* and the *Heritage* as we slowly paddled toward these stunning tall ships. Both vessels appeared ghostly, with no evident human activity. The passengers and crew apparently were asleep, missing a gorgeous sunrise. We paddled around the schooners, curiously exploring the details of each one. We touched the smooth wooden planks of the hulls and felt the jagged anchor chains.

We returned to Marshall Point refreshed and rejuvenated, ready to take on the world. At the least, we were ready to tackle another workday. It was 6:30, and the day was just beginning.

— Tom and Lee

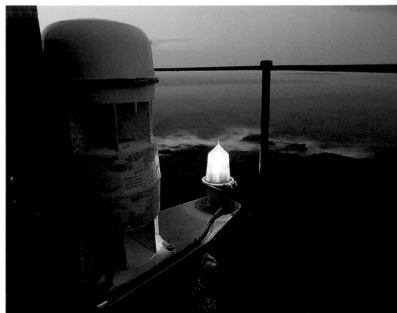

The diminutive emergency backup light

July 23

Last Tuesday, I returned home under an ominous sky and looming storm. By the time I reached the keeper's house, the rain was descending in pelting sheets, a consistent rumble of thunder reverberated, the wind agitated the ocean, and the foghorn bellowed. Relishing the tempest from our first-floor porch, and waiting for the storm's departure, I felt isolated and inspired.

After a few minutes, I realized that this thunderstorm was not leaving quickly. Oh, how I wished Tom were here to experience it with me. But he wasn't, so I decided to document it for him with our video camera. Back inside, I rushed from window to window, filming the storm. I considered focusing solely on the light tower in the event that lightning might strike it, but instead I sat near a parlor window, keeping the camera rolling.

Suddenly, I heard a startling crack. I immediately knew that lightning had struck the tower. During previous storms, I had heard the unsettling blast of a strike on the lightning rod atop the tower. When I looked out a window facing the tower, I saw that the lantern room was dark. The emergency backup light on the ocean side of the tower was now serving as the only beacon of safety and security for mariners. The sound of the lightning strike, which I had captured with the camera, was stunning. Tom described it as "unbelievable" when he later watched the video.

~ *Lee*

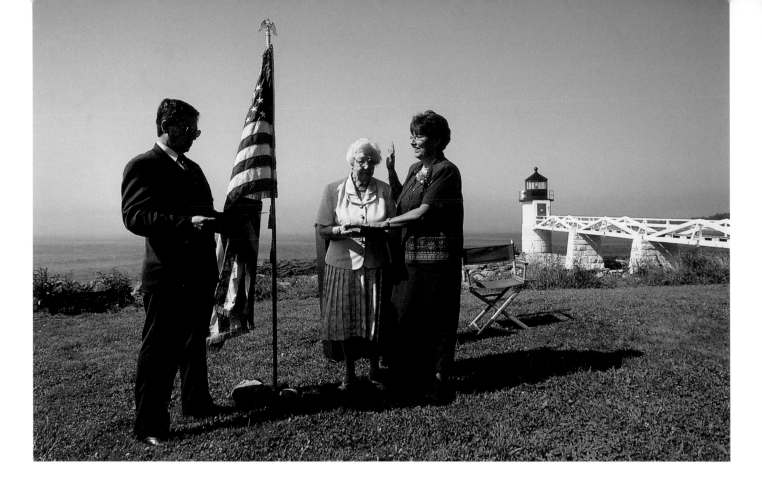

August 8

Nearly fifty friends, family members, and neighbors gathered this morning at the point to witness the swearing-in ceremony of Sandra Hall as the new postmaster of Port Clyde. Flower bouquets, a cake, and gifts were set out on the picnic tables, and each arriving guest received a program. Sandra's ninety-year-old grandmother, Etta Hall, held a Bible on which Sandra placed her hand during the installation.

When I asked Sandra why she had chosen Marshall Point for the location of the ceremony, she enthusiastically replied, "Where else would you go in Port Clyde?"

~ *Tom*

August 14

This morning, I observed the two-masted schooner *Grace Bailey* from my office window in downtown Camden—only to arrive home this evening to watch the same graceful vessel sail past my kitchen window at the keeper's house.

~ *Lee*

January 1, 2001

We began our journey into the new year by waking up at 6 a.m. and watching the subtle colors of sunrise change before our eyes. Minutes later, we gathered our long underwear, heavy wool socks, and winter coats to walk down the road to Drift-In Beach. The three-mile round-trip was peaceful and invigorating. As we approached the beach, a lone harbor seal joined us, while black-capped chickadees flitted about the nearby woods.

We returned to the keeper's house at 9 a.m. to prepare for another simple yet fascinating aspect of our lives here. At 10 a.m., a couple neither of us had met before was scheduled to arrive to be married at the lighthouse. This is not an uncommon occurrence, of course. What was unusual about today's wedding was that the groom had asked us to be the legal witnesses and sign the marriage license.

The event began to unfold last week when the groom-to-be, Joseph Edward Lebherz, asked permission to marry Elsie Bengston inside the keeper's house. The wedding party would be small and the ceremony short and informal, so I didn't see any reason why he and Elsie could not begin their married life in our home. Joe was exceptionally grateful and pleasantly surprised when we agreed to his request. We were surprised in turn when Joe asked if Lee Ann and I would be their witnesses. Flattered by his request, we gladly agreed.

The couple arrived at the lighthouse in casual dress. They had just recently moved to Friendship, Maine, from Cape Cod, Massachusetts. The only others who joined us were the officiating notary public and his wife.

After everyone exchanged pleasantries, the couple were married in a five-minute ceremony in the front room of the first floor. Lee Ann presented the newlyweds with a wedding gift and card. Inside the card she had written: "Best wishes on your wedding day and throughout your life together. May the light of your love for one another shine brightly within your hearts."

Mr. and Mrs. Joseph Edward Lebherz departed forty-five minutes after their arrival, expressing their appreciation to us for their dream wedding.

~ Tom

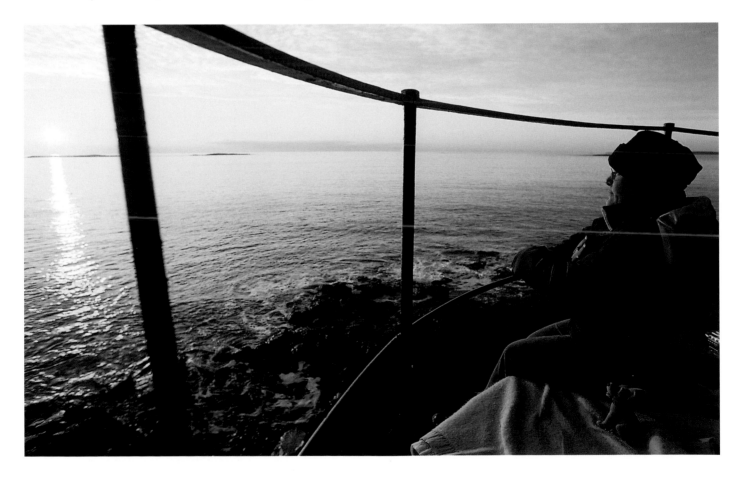

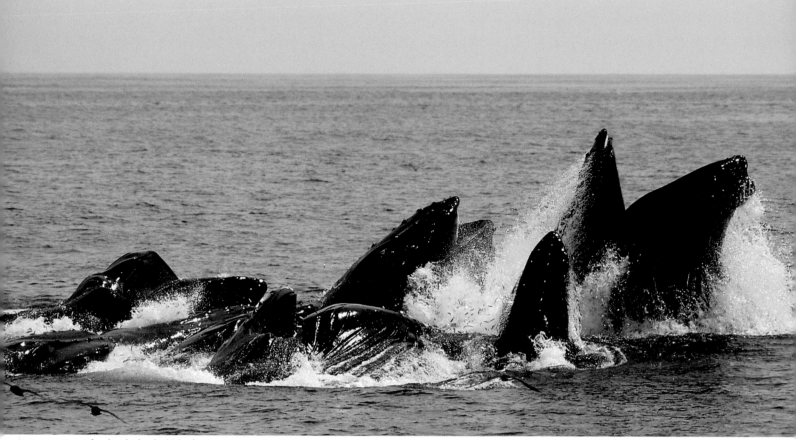

Humpback whales bubble-feeding in the Gulf of Maine fling clouds of spray laced with myriad small fish.

June 21

Today I experienced the most incredible event that has occurred in our twelve years of residing at Marshall Point. Nothing can match it. From the parlor windows, I watched in utter disbelief as a huge shape emerged from the ocean near Gunning Rocks Ledge three-quarters of a mile offshore. A whale's arched back surfaced, its massive hulk surging out of the water. The behemoth—a forty-five- to fifty-five-foot humpback whale—surfaced several times, exhaling a tall stream of moisture-condensed breath.

I soon lost sight of it behind the ledge, but I saw several immense splashes. I knew that only a breaching whale could have been causing those stupendous displays.

Then the humpback reappeared from behind the ledge to give me the show of a lifetime. It breached more than two dozen times, displaying behavior I'd never seen before—and certainly never from the comfort of my home. I was numb with emotion, watching in astonishment as the whale reared its thirty-ton body into the air. Each time it hit the water, it took several seconds for the sound of the impact to reach me. The muffled, shotgun-like sound is one I won't soon forget, and I can only hope I will someday hear it again. I dared not leave my seat to retrieve my camera and telephoto lens for fear of losing sight of the whale.

The whale traveled slowly between Old Cilley Ledge and Black Rock Ledge, stopping occasionally to breach. A nearby commercial fishing boat paused only briefly to view the spectacle. After about forty-five minutes, as my eyes were tiring and a layer of haze had begun to obscure visibility, the whale finally disappeared.

It's now been two hours since I last saw the whale. I will remain sitting near the window for another two hours, until darkness arrives. I am determined not to miss the whale if it reappears.

Today's sighting was the first humpback we have ever observed from the point and only the fourth whale we have seen in the years we have lived here.

⤙ Tom

May 2, 2002

*A*s I wash the floor on the first floor of the keeper's house this afternoon I am vividly reminded why I love Marshall Point. Pausing with the mop in my hand, I listen to the howl of the brisk wind as it forces a steady rain onto the large picture windows. I am alone on the point during the storm, performing my keeper's duties. Just the rugged elements, historic lighthouse, and me.

Five years ago, we purchased sixty-seven acres of land in Whitefield, looking ahead to when we would build our first and last home together. Now our new home is ready, and our fairy tale will continue in a log cabin in the woods of Maine.

I've tried to convince myself that I will not miss this heavenly location, but who am I kidding? I will miss it. I will never forget Marshall Point. The decision to move was not an easy one for us, but we will take with us thirteen extraordinary years of memories, journal entries such as this, and the photographs I've created.

⌒ Tom

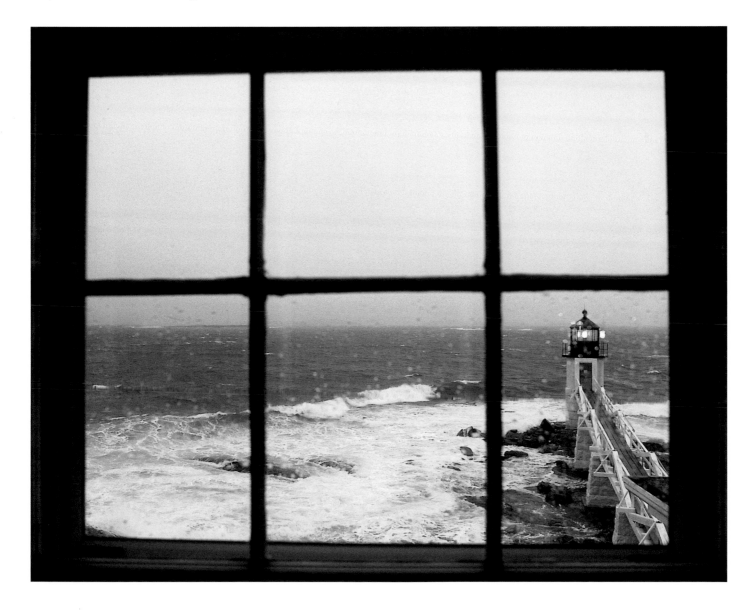

May 29

Last night, while we were sitting near a parlor window watching the nightly harbor seal show, an immature bald eagle flew over a seal swimming near The Brothers Ledges. Hundreds of black-backed and herring gulls gathered in the air above the eagle, abandoning their nests on the nearby islands. Using our binoculars, we watched the seal drive a large school of fish to the surface. The eagle was attempting to capture one of these fish in its razor-sharp talons, even grabbing for a fish only inches from the seal's head. After several tries, the bird was successful, leaving the rest of the schooling fish for the gulls, which now numbered in the thousands—in the sky, on the ledges, and on the surface of the sea. Other fish-eaters joined the frenzy, including cormorants, guillemots, an osprey—and even a loon, an uncommon sight on salt water this time of year.

— *Tom*

A black guillemot brings fresh food to its young.

December 31

This is not only the last journal entry of this year but also the final entry for us as keepers of Marshall Point Light. I'm writing this passage in our new home, a log cabin in the Maine woods, fondly reflecting on my thoughts from this morning's final minutes in the keeper's house at Marshall Point.

Today was my last time at the lighthouse, where I had to complete one more chore—moving my piano out of the house. I had hired expert movers to assist with this difficult task, and they arrived fifty minutes late. Although I was

frustrated by their tardiness, those fifty minutes allowed me to say good-bye to our fairy-tale home for so many years.

As I gazed out the windows, the falling rain mirrored the tears I shed and slowly melted the snow cover and my heart. I was bidding a sad farewell to Marshall Point not because I'll miss the glorious seascape or the ever-changing skies, or because I became part of the history and tradition of this significant structure. I'll miss it for one simple reason, which I learned years ago from our neighbor Marion Dalrymple, the daughter of the longest-tenured lightkeeper at Marshall Point. Asked by a television reporter what it is like to live in a lighthouse, she replied, "It was simply our home." And that is why I will miss Marshall Point—it was simply our home for almost fourteen glorious years.

One last time, I glanced out the bedroom window, a view etched in my memory forever.

—Lee

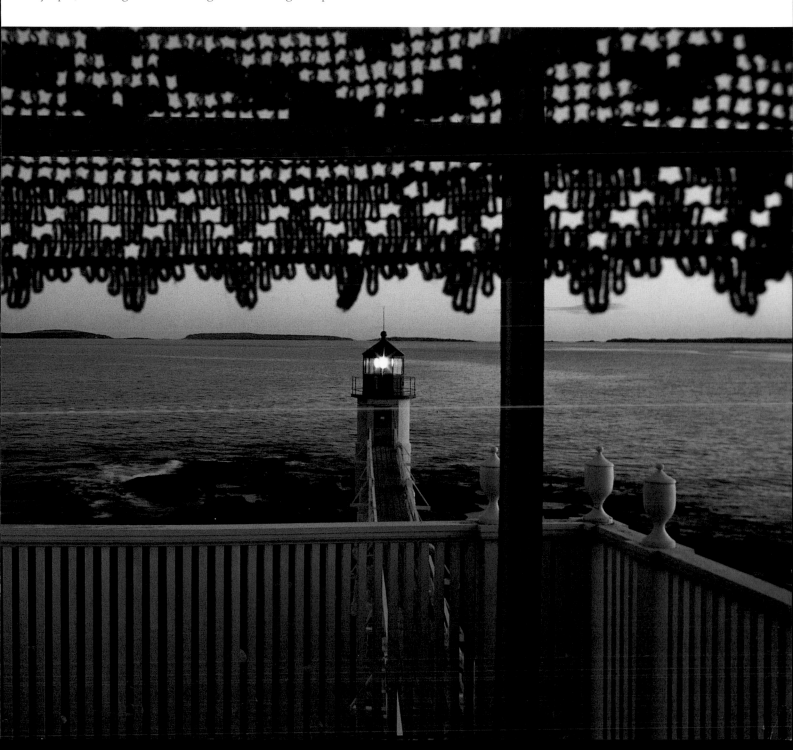

Acknowledgments

Our dream of living in a lighthouse would not have happened without the wisdom, foresight, and support of many individuals. Lee Ann's parents, Arthur and Ann Guesman, introduced her at an early age to her first lighthouse, Chatham Light, when her family vacationed on Cape Cod. The courage and perseverance of her grandmother, Bubby, guided her toward realizing her dream of living at Marshall Point.

We would not have been able to write our story without the assistance of the St. George Historical Society and the Marshall Point Lighthouse Museum.

We are grateful to the community of Port Clyde and our friends and neighbors: Peter Achorn; Betty Balano; Tom and Joanne Barksdale; Judy and Jim Barstow; Laurie, Jeff, and Dustin Bouchard; Joanne Campbell; Lucky, Claire, and Rob Clark (Lake Champlain lightkeepers); Patti and Victor Cole; Paul Coughlin; the Cushman Clan; Marion Dalrymple; Paul Dalrymple (We are the secret penguin); Syd and Mary Davis; Bill and Hattie Dennen (Thanks for the rescue); Sue and Dick Eichacker; Carol Emery; Bob and Eloise Ensor; Doug and Pauline Erickson; John Falla; Frank and Grethe Goodwin; Marion Gray (Wonderful hydrangea); Norm and Judy Grossman; Joan Hall; Goper and Jaye Haupt; Archie and Carol Higgins; Denise Hippert; Dorothy Jackson; Ann and Treby Johnson (Thanks for sending the ghosts and goblins our way); Karen, the FedEx Lady; Eula Kelley; Ray LaFrance; Fred and Mary Lord; Nancy Lunt; Greg and Nadine Mort; Ozzie and Joyce-Karen Oswald; Ken Parker (The ocean water is cold, huh?); Judy Parsons; Dave Percival; Vera Rand; Captain H.C. (Skip) and Jane Scarpino (Always nice to see you every day); Bob and Anita Siegenthaler (Happy New Year); Jim Skoglund; Dana and Flora Smith (Have you learned to use your computer yet?); John and Ann Snow (It's a small world); Janet Snyder; Scott Stanton; Karl Turgeon; Andy and Rob VanderMolen (Remember Hugo?); and Dorcas Zeiner. Also Dawna, Reggie, Pearl, Moxie, and Olive, and of course the lighthouse cats, Puffin and Dupa.

Our sincere gratitude goes to those we had the privilege of meeting at Marshall Point: Ken Black; Chris Burt (What a week we had; remember the shooting star and Carlos?); Robert Clark (Enough photos yet?); Tom Clegg; Tom Dutton (Aloha!); Arthur Godjikian; June Lockhart (George Washington may not have slept at Marshall Point Lighthouse, but you bathed here. We treasure our friendship and the lifetime of memories you graciously shared with us); our friends at Monte Cassino Elementary School in Tulsa, Oklahoma; the Flying Santa (aka George Morgan); Paul Roberts (Great lobster . . . wipe that butter from your face); Al and Jo Schuckle and family (Cheers!); Brian Tague; Jerry Zelinger; and Scooter the lighthouse dog (Bad dog for eating our pumpkin!).

We appreciate the assistance from and support provided by the following individuals and companies: Tom Frost, The Chimera Company; Michael Hess; Steve Hess; John Magoon and Scott E. Magoon, University Products; Bushnell Corporation; and Tamron U.S.A., Inc.

Many thanks to the folks at Down East Books, especially Neale Sweet and Karin Womer, for recognizing the uniqueness of *Our Point of View* and giving us the opportunity to share our life and dream with thousands of other dreamers. For their design and editing work, thanks go to Lynda Chilton and Kathy Brandes, respectively.

Tom will never forget those who were kind enough to allow him to photograph them at Marshall Point.

Finally, Tom is especially thankful to his wife, Lee Ann, for her devotion, encouragement, guidance, patience, assistance, inspiration, and love. She is a contemporary Abbie Burgess.

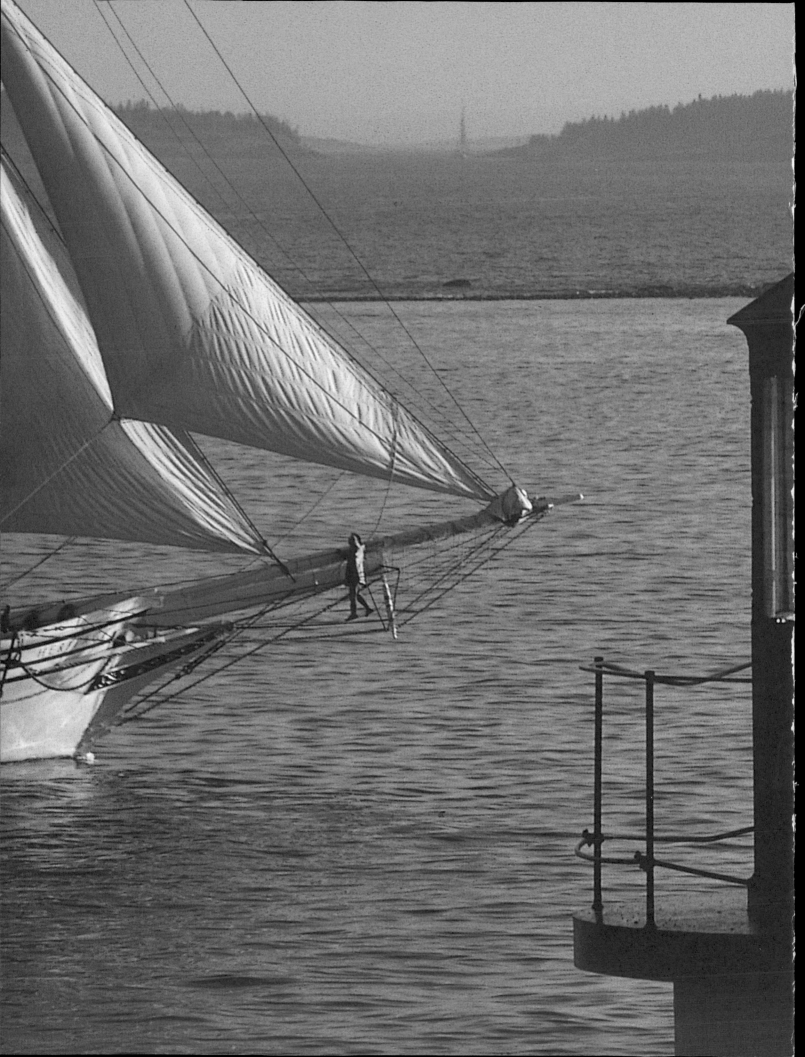